THE
SMITHSONIAN
CASTLE AND THE
SENECA QUARRY

GARRETT PECK

THE
History
PRESS

Published by The History Press
Charleston, SC 29403
www.historypress.net

Front Cover: Stonecutting Mill Window. *Photo Courtesy of Garrett Peck.*

First published 2013

Manufactured in the United States

ISBN 978.1.60949.929.7

Library of Congress CIP data applied for.

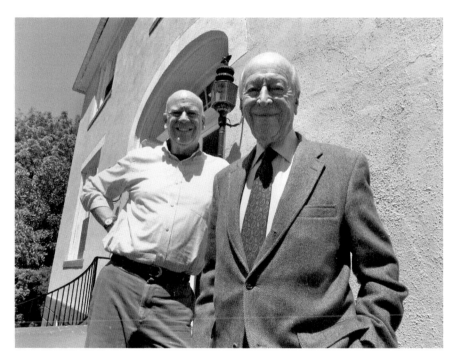

Knight and Austin Kiplinger at their Montevideo home. *Courtesy of the author*.

To Austin and Knight Kiplinger.
And to all who work to save Seneca.

Contents

Foreword

Upon seeing the still unfinished Smithsonian Castle silhouetted against the U.S. Capitol in the distance in 1851, American sculptor Horatio Greenough wrote: "Tower and battlement, and all that medieval confusion, stamped itself on the halls of Congress, as ink on paper! Dark on that whiteness—complication on that simplicity!" The appearance of the building was shocking not only for its architectural style, a radical departure from the classical, but also for the choice of building material: Seneca red sandstone.

Yet this Seneca sandstone was not the architect's first choice to clad the exterior of his Romanesque masterpiece. James Renwick Jr. envisioned a white marble façade, as evidenced by the model he submitted to the Smithsonian's building committee and board of regents. The model is on display in the castle's Great Hall. Seeing it is aesthetic proof that the dark, brooding color of Seneca red sandstone suits to a tee the medieval style. Combine that with the practical considerations that author Garrett Peck lays out in this book and it becomes apparent that it was the perfect choice of building material for the structure.

Until now, little was known about the day-to-day operations or history of the quarry that supplied the stone for the Smithsonian's first building. Garrett Peck has endeavored to cast a light on the owners, the workers, the origins of Seneca quarry and its relationship to the C&O Canal and the Smithsonian Building. He manages to fit it all into the greater political and economic contexts of the day, the Civil War and the rapid expansion of Washington.

The threats of destruction and ruin from floods, war, financial collapse and political scandal involving a sitting U.S. president all make this a story as tangled as the vines and wild roses that have overtaken the quarry today. The quarry and canal that served to transport the stone to Washington would eventually outlive their usefulness and fall into disuse and disrepair. Today, the quarry is barely visible due to thick undergrowth and a canopy of trees. The once thriving concerns that turned the small community of Seneca, Maryland, into a bustling little company town are now long gone, and their remnants have fallen into ruin. What the threatening disasters of the previous centuries could not accomplish, benign neglect is successfully finishing. The Seneca quarry is protected from encroaching development but not from the consumptive forces of nature.

There is hope, however, and Garrett Peck makes the case for the preservation and partial restoration of the sites. It is his hope that a better public awareness of the historical importance of these sites will help preserve them. Otherwise, they will become the archaeological digs of future generations or—worse—forgotten entirely.

Richard Stamm
Smithsonian Castle Collection Curator

Acknowledgements

I discovered the largely forgotten Seneca quarry while researching my third book, *The Potomac River: A History and Guide*. Shortly after it was published, I ventured to the site with Rebecca Sheir of WAMU's Metro Connection to produce a radio segment. We met Bob Albiol, who restored the quarry master's house overlooking the quarry. My numerous visits to the quarry left me unsettled. The abandoned and crumbling stonecutting mill and the overgrown quarry called out for their story to be told.

Researching a book consumes an enormous amount of time, much of it alone, but it is also a social activity. You get to meet wonderful archivists, curators, historians and people who have restored old buildings. Writing this book has been an exercise in literary journalism. My exceptionally long list of people to thank begins with Rick Stamm, the Smithsonian Castle curator, who opened his treasure-trove of photos. His predecessor, James Goode, provided his encyclopedic memory of the castle's history, its preservation and the fascinating tale of the Renwick Gate's construction. Ellen Alers of the Smithsonian Archives was unbelievably helpful in tracking down images. Robyn Einhorn of the Smithsonian's National Museum of American History bent over backward to get photos of the Smithson coins.

Stone restoration specialist Clift Seferlis showed me the work he did on the Smithsonian Castle and shared many stories about his stone-carving father, Constantine. Clift is a master of puns and often left me chuckling, such as the time he described removing the D.C. Jail façade as a "reverse façademy." He's a local tour guide as well—look him up!

ACKNOWLEDGEMENTS

In the Seneca Historic District are numerous redstone buildings maintained by preservation-minded people who opened their doors and shared their stories. Austin and Knight Kiplinger welcomed me to Montevideo, the home of quarry owner John P.C. Peter, and provided details of their family history at Seneca and their considerable restoration work. And if Knight ever volunteers to review your manuscript, take him up on the offer! He's a fabulous editor and incredibly passionate about local history. Bob Albiol opened the quarry master's house and took me around the quarry on numerous occasions. Andrea Willey and her son, Andrew, provided a tour of the Montevideo overseer's house, while Janis Glenn of Rocklands Farm showed me all around her family's beautiful farm and neighborhood along Montevideo Road.

Just up the road is St. Paul Community Church, where Gwen Hebron Reese has documented the Sugarland black community through the Sugarland Ethno History Project. Gwen shared her vast knowledge of African American history in the Seneca area. Rande Davis, the executive director of the Historic Medley District, helped me identify the many Seneca redstone buildings in the district.

Tom Kuehhas and Pat Andersen of the Montgomery County Historical Society steered me through an entire library of information. Most counties would be envious of these excellent archives. Clare Kelly of the Maryland-National Capital Park and Planning Commission (M-NCPPC) helped me find three rare photos of the Seneca quarry. Between M-NCPPC and the local historical society, Montgomery County has a tremendous archival record of its past.

The State of Maryland has a commitment to historic preservation, and you see that in the excellence of its employees. Kim Lloyd of the department of natural resources is the park manager for Seneca Creek State Park. Charlie Mazurek is the historic preservation planner at DNR, while Emily Burrows runs the Resident Curatorship Program, which includes the quarry master's house. It's rare that we ever thank our public employees, but I am one person who is immensely grateful for the work that you do.

Mike Robbins was part of the Smithsonian expedition to survey the Seneca quarry in January 1968, and he shared his memories of visiting the quarry. Karen Gray, a C&O Canal headquarters library volunteer, opened the archives to me and suggested that I visit the National Archives—two research trips that bore great fruit. Joe Smoot of the U.S. Geological Survey explained how red sandstone came to be made more than two hundred million years ago.

Ella Pozell of Oak Hill Cemetery opened the archives of one of the District's loveliest cemeteries, a place that has four—count 'em, four—Seneca structures. Peter Braun, director of operations at the Lab School of Washington, explained the history and restoration of the area's quirkiest Romanesque building. Patty Gamby and Glenn Taylor of Washington Aqueduct literally opened the gates so I could photograph Cabin John Bridge. Steve Livengood of the U.S. Capitol Historical Society got up early one morning to lead me on a private tour of Seneca redstone in the Capitol Rotunda.

This is starting to sound like an Oscar acceptance speech, but I swear it's almost done.

Two people have been my eyes and ears for all things Seneca redstone: John DeFerrari, author of *Lost Washington, D.C.* and blogger of Streets of Washington; and Jerry McCoy of the Washingtoniana Collection and the D.C. Public Library's Peabody Room.

Kenny Allen once again scripted an awesome accompanying map. May many people follow it to explore this forgotten site. And lastly, thanks to my amazing editor, Hannah Cassilly, who puts more faith in me than I probably deserve. You have my deepest gratitude.

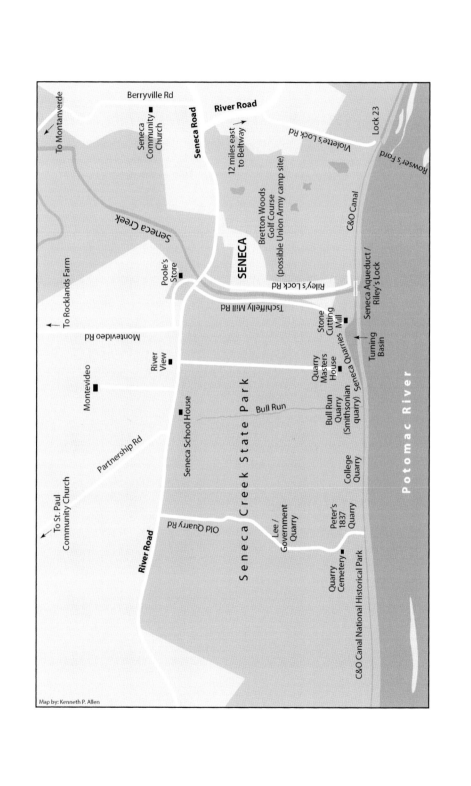

Map by: Kenneth P. Allen

To Montanverde

Berryville Rd

Seneca Community Church

Seneca Road

River Road

12 miles east to Beltway

Violette's Lock Rd

Lock 23

Rowser's Ford

Seneca Creek

Bretton Woods Golf Course (possible Union Army camp site)

C&O Canal

To Rocklands Farm

Poole's Store

SENECA

Montevideo Rd

To St. Paul Community Church

Montevideo

River View

Partnership Rd

Tschiffely Mill Rd

Riley's Lock Rd

Seneca Aqueduct / Riley's Lock

Stone Cutting Mill

Turning Basin

Seneca School House

Seneca Creek State Park

Bull Run

Quarry Masters House

Seneca Quarries

Bull Run Quarry (Smithsonian quarry)

River Road

Old Quarry Rd

Lee / Government Quarry

College Quarry

Peter's 1837 Quarry

Quarry Cemetery

C&O Canal National Historical Park

Potomac River

Introduction

The village of Seneca lies about twenty miles up the Potomac River from Washington, D.C., in the rolling hillsides known as the Maryland Piedmont. A once thriving commercial town in Montgomery County, Seneca was a hub of nineteenth-century activity. Farmers brought their grain to be milled, C&O Canal boats carried goods down the watery highway to Washington and men hammered and chiseled away at the red cliffs west of town just above the canal. Seneca was a famed quarry in its day.

Not a sign indicates where the quarry is or interprets its long history—you just have to know it's there. Hang around on the C&O towpath long enough and you'll see dozens of people walk or ride their bikes past. Few have ever heard of the Seneca quarry, and almost no one realizes they are so close. It may as well not exist.

Yet out of the long-forgotten Seneca quarry came that most wondrous building material: red sandstone. It decorates the exterior of the Smithsonian Castle—that distinctly rusty red building on the National Mall—as well as hundreds of buildings constructed during the five decades of Victorian architecture in Washington. A few that come to mind include Luther Place Memorial Church, the Lab School "castle," the Center Building at St. Elizabeths and the Renwick Chapel at Oak Hill Cemetery. But it was a boom-and-bust ride for the quarry, which opened and closed, went bankrupt twice, suffered through numerous Potomac River floods and contributed to a national scandal that embarrassed the Ulysses S. Grant presidency and helped bring down the Freedman's Bank.

Seneca red sandstone, also known as redstone, is the color of rust—but not uniformly. There were a number of reddish hues that came from Seneca: pink, light brown, rust, lilac grey and ruddy brown. One quarry

even provided bluestone for Georgetown University. Identifying Seneca buildings can be difficult; they aren't always the same color.

We really can't speak of just one Seneca quarry. There were numerous quarries along a one-mile stretch of the Potomac River just west of Seneca Creek. The Potomac carved out the side of this sandstone ridge, exposing the rock to stonecutters. Around the United States, you can see quarries dug into the ground and filled with water like swimming pools. Not so with the Seneca quarries, which were dug into the cliff side. They sit above the water table.

When the Seneca quarries were operating, there were probably few trees in the area. They were cut down for building, cooking and farming. After the quarry closed in 1901, the forest grew back. The quarry site has been taken over by sycamore trees, dense brush and poison ivy. It is impenetrable throughout much of the year—you have to wait for the leaves to fall to explore the site. But the stonecutting mill is easy enough to enter, as it sits right off Tschiffely Mill Road.

The town of Seneca once provided housing for canal and quarry workers, gristmills for local farmers and many other services—including a good time out for rowdy workers. It built a school to educate local white children. Segregated African American communities—composed of descendants of emancipated slaves—lived nearby on Violette's Lock Road and in Sugarland. There's not much left of Seneca today, just Poole's Store and a few houses.

To visit the Seneca quarry, you travel a dozen miles west along River Road from the Beltway (I-495) through the ritzy enclave of Potomac past Blockhouse Point Conservation Park, where Union forces kept their watch on "Mosby's Confederacy" across the river during the Civil War. When you see signs for Violette's Lock Road and Bretton Woods Golf Course, you're getting close. Just before reaching Seneca Creek, take a left on Riley's Lock Road, which dead-ends at Seneca Aqueduct at mile marker 22.7 on the C&O Canal. The quarry is just a few hundred feet to the west, though hidden deep in the woods and unmarked above the canal's turning basin. Seneca quarry sits entirely within the C&O Canal National Historical Park. At the top of the quarry, the land changes ownership to Seneca Creek State Park, part of Maryland's Department of Natural Resources.

Researching the Seneca quarry is a challenge. There are no quarry company records. Nor has a formal history of the quarry been written before. The only histories we have are a 1968 article in the *Smithsonian Journal of History* and a 1978 master's thesis on the quarry master's house by Janine Cutchin. The quarry's history had to be pieced together through

C&O Canal records, contemporary newspaper articles, searching through every imaginable archive in the Washington area and interviewing people involved in Seneca preservation. This book is based almost entirely on primary research.

This is the story of the once famous Seneca quarry that brightened the Washington skyline. It is the story of a preservationist who pursued a Sisyphean task, single-handedly restoring the quarry master's house. It is the story of a publishing family who put philanthropy first to preserve the Seneca Historic District's bucolic nature. And it is the story of the descendants of freed slaves and quarry workers who are bound together in community. Though the Seneca quarry closed, its story continues.

The Quarry Master

D riving west on River Road, you climb a steep hill just after crossing
Seneca Creek. As you reach the crest, there's a simple mailbox on
the left marked "Albiol." Turn left at the mailbox and follow the dirt road
past farmland until it dead-ends at a bright red sandstone house in a stand
of trees. It is the quarry master's house, home of the superintendents who
managed the day-to-day operations at Seneca quarry. "My driveway is a
mile long," Bob Albiol joked. (It's actually 3,800 feet.)

Albiol was born in Bolivia, though you'd never guess it—he's tall and
fair with no discernible accent. A self-described "starry-eyed anthropologist"
and preservation consultant, Bob and his physician wife, Loreto, live in the
quarry master's house. It is much more than a home to them—they restored
the house from a virtual ruin into a livable dwelling.

Maryland founded its Resident Curatorship Program in 1982 to allow
people to move into dilapidated historic properties and fix them up at
their expense. The state retains ownership, while the tenants live rent-free
for life. More than sixty structures are protected this way. "It's a historic
preservation program, but we also rely on our curators to monitor the
land. They really are our partners in every sense," said Emily Burrows,
who manages the program.

The Resident Curatorship Program was just two years old when the
Albiols first visited the quarry master's house in 1984. The house was a mess.
"Kids came in here to do what they couldn't do elsewhere," Bob explained.
There were signs of beer cans, bonfires, condoms and drugs—even a

swastika painted on a wall. Despite the terrible condition of the property, the Albiols fell in love with the house. "I came out to this property and said, 'This is the one for me,'" Bob remarked. The Albiols became one of the first three resident curators in Maryland.

Though the Albiols moved into the house in 1986, it took about six years to renovate the property. They used original materials, including stones around the building, to reconstruct the demolished parts of the house. "We put it back the way it was, with the exception of plumbing and heating," he said. He has a photo album that documents years of restoration efforts and includes heartbreaking photos of the overgrown ruins. They sunk a small fortune of their own money into the house. "It doesn't finish—you're never finished," Albiol explained.

In addition, Albiol found three neglected historic log cabins and brought these to the property. He located two near Damascus, Maryland. The smaller is about the size of a shed and sits in the garden. The larger cabin fit exactly on the footprint of an earlier demolished structure attached to the quarry master's house, so Albiol positioned it there. The third cabin was built in 1748 near Frederick, Maryland, and was deteriorating on private property. He moved it behind the main house. The Albiols intended it as an in-law suite, but then their parents died, so they use it as a guesthouse.

The quarry master's house may have been built around 1830, the same year that the C&O Canal reached Seneca. It was built as a duplex for two quarry masters, as the quarry had two daily shifts. The house sits right above the main quarry and overlooks the canal turning basin. It must have been a noisy place to raise a family. Albiol pointed out that the house shows off many different styles of stonecutting. A prospective stone buyer could view the house and decide what styles of finishes best suited his needs. It was like a sample sale on walls.

Bob Albiol knows the quarry better than anyone, having lived above it for decades, and he makes an excellent guide. He advises to wear heavy footwear and warns against snakes. There are occasional copperheads underfoot—they blend in with the leaves on the ground—but unless trapped they slither away before you ever see them. Black snakes are also common. These large non-poisonous snakes make meals out of bird nests, copperheads, mice and rats.

The quarry master's house is right above the largest quarry, the "big quarry," as Albiol calls it. It stretches above the turning basin and is more than a quarter-mile wide. This was where much of the post–Civil War quarrying took place at Seneca. We climbed down a deer path into the

big quarry and crossed several boggy runs, one from a natural spring that provided fresh water for the workers. We soon found a path along the north side of the turning basin, which is shaped like the state of Virginia when viewed from the air or a satellite map.

Then came the most surprising discovery: a thicket of domesticated plants such as daffodils and periwinkles that grow right in the quarry. Albiol explained that there must have been a house nearby whose owners loved to garden. Imagine—a house in the quarry. What an unusual place to find such a domestic scene. Though the house is long gone, these garden plants remind us that the Seneca quarry once teemed with people.

Albiol led the way to the base of the big quarry. We looked up to the red cliffs that towered forty or fifty feet above. Up close, you can see the wondrous layers of red sandstone and even pick out chisel marks and grooves from the tools that split the rock. There must have once been a loud din from the constant hammering, the crunch of rock falling from the cliff, the shouts of foremen and the brays of mules. Today, there is only silence, save for the wind rustling the leaves.

All around us were enormous sycamore trees with their distinct white bark, as well as a few tulip poplars. Pawpaw trees, with their mango-tasting fruit, also thrive in this shady environment. There was an incredible amount of brush underfoot, especially wild rose that grabs onto your clothes. Albiol pointed at the wild vines growing up some trees. Poison ivy is present but not prevalent; it is easy to spot with its three leaves and hairy-looking vines. ("Leaves of three, let them be!")

Just east of the turning basin is the stonecutting mill, constructed of red sandstone quarried on site. It may have been built around 1837. The Seneca Sandstone Company either expanded the mill or built a new mill in 1868—we aren't sure which—but it quadrupled the size of the old mill. The building was clearly built in two sections; much of the rear section is more primitive rubble, while the front portion tends to be smooth ashlar. The stonecutting mill now sits in the overgrown forest, crumbling away and tagged with graffiti, like some ruin from ancient Rome. It is these ruins that we now see just off Tschiffely Mill Road. Trees grow all around the mill, worrying many that if (and when) they fall, they will damage the ruins.

In 1999, a project to expand the protection buffer around Lafayette Square revealed Seneca redstone piers that anchored an 1853 fence. The White House donated them to the C&O Canal National Historical Park. They lie, neatly stacked in rows, along Tschiffely Mill Road, a few dozen yards north of the stonecutting mill.

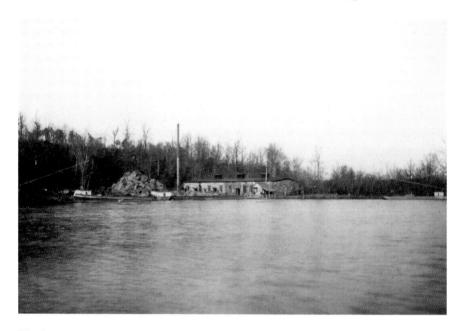

The Seneca stonecutting mill and turning basin around 1890. *Courtesy of M-NCPPC Historic Preservation, Michael Dwyer Collection, O'Rourke family photo.*

It was the building of the C&O Canal that turned this isolated quarry into a commercial operation. The canal and the quarry had a symbiotic relationship. Not only did the mill draw its power from canal water (the quarry rented water on an annual basis), but it also used the canal to haul the finished blocks to Washington, enabling Seneca sandstone to reach the market in an era before trains or flatbed trucks.

Bob Albiol notes the importance of canals, as roads back then were often just tracks through the woods. "I've lived a lot of my life along dirt roads. You can't drive wagons along dirt roads when it's raining," he explained. The first wagon creates a rut, the second turns it into mud and soon the road is impassable to wagons that follow. Without the C&O Canal, there simply would be no Seneca quarry.

THE QUARRY AT WORK

Sandstone is a stratified rock. That is, it has layers and a grain to it. Stonecutters learned to use the layers to their advantage, as they could

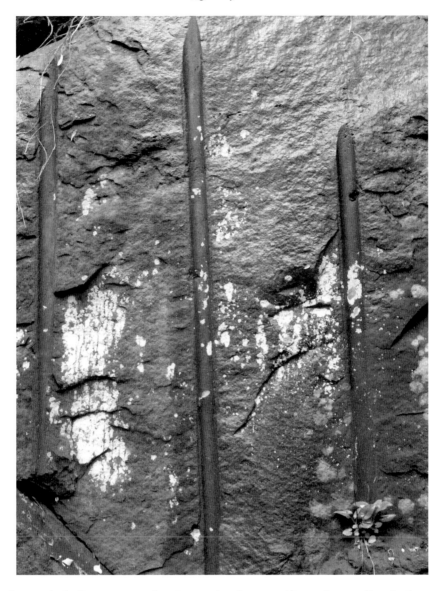

Grooves in the Seneca quarry show how workers hammered iron spikes to split rock. *Courtesy of the author.*

cut the stone along the grain. They used techniques that hadn't changed much since ancient days. A team of three workers hammered iron rods vertically into the rock, each a foot apart, and then inserted wedges into the holes to split the rock from the cliff. The rock would split on its bed, freeing the entire block.

Claude Owen, a local resident who was a youth in the final years of the quarry's operation, later recalled, "I have seen a colored man sit on a large block of stone, sometimes as large as a six or seven foot cube, with three powerfully built colored men armed with heavy sledge hammers striking, in rhythm, a drill the seated man held in his hands. The slightest miscalculation by either of the three men meant a badly broken leg, but it seems never to have happened."

In fact, accidents must have happened—there are believed to be more than one hundred people buried at the quarry cemetery, and not all of them lived to old age. (The cemetery was a mile west of Seneca Creek, adjacent to the quarry that John P.C. Peter purchased in 1837.) Alice Nourse was married to the local physician who supported the quarry. She later recalled, "The men were taxed one dollar per month whether sick or well for his services. At the quarry there was constant blasting…which resulted in many accidents." Blasting was done more typically with granite, which isn't stratified or layered, but may have been done in the Seneca area as well.

After the stone was cut away from the cliff, the rough blocks were cut on-site with a hammer and chisel into irregular-shaped rubble or ashlar, which were symmetrical blocks that were cut and polished in the stonecutting mill to exact specifications.

A series of derricks was erected in the quarry, like early versions of construction cranes. Cables were attached to their crowns; some linked to derricks, while others secured them to the ground via large anchors. Quarry workers wrapped a stone block in a metal cage before attaching a cable to a derrick. A long arm capped with pulleys extended from each derrick to lift a stone block. The derrick would pivot around, passing the stone to the next derrick until the stone could be lowered into a gondola on a narrow-gauge track. A mule or a group of men then pulled the cart to the mill for shaping and polishing. A small segment of the railway can still be seen above the quarry.

Electricity didn't come to Seneca until 1934. The stonecutting mill was never electrified—it relied initially on a breast wheel and then later on water power. The quarry rented water from the C&O Canal, drawing from the turning basin using a water wheel and possibly a steam pump to power the machinery. A six-foot steel saw cut back and forth while a pipe dripped water to keep the saw cool. The saw could cut an inch per hour. There were also other saws to create the special finishes that customers demanded. For a smoothly finished stone, the cut rock was placed on a rotating disk while a steel blade buffed and polished its face. The water then flowed into the

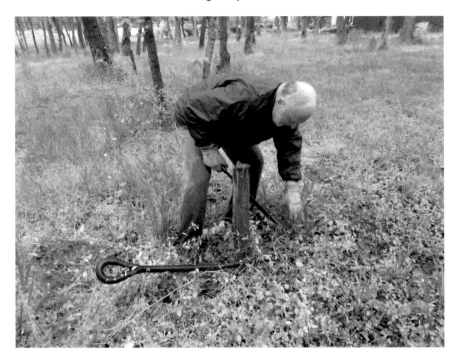

Bob Albiol inspects a derrick anchor above the Seneca quarry. *Courtesy of the author.*

Derricks lifted heavy stone blocks using pulleys. Cables anchored them to the ground and other derricks. *Courtesy of M-NCPPC Historic Preservation, Michael Dwyer Collection, O'Rourke family photo.*

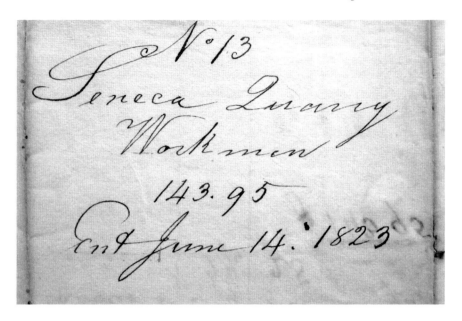

An 1823 government payroll from the Seneca quarry. *Courtesy of National Archives and Records Administration.*

millrace and into Seneca Creek. The millrace is still clearly visible. The finished stone was then loaded on canalboats docked in the turning basin and shipped to Washington. They could reach the city in as little as a day.

How many people worked at the quarry? We simply don't know. The only payroll I could find was a government payroll from 1823 located at the National Archives, probably from quarrying for the U.S. Capitol Rotunda or the White House north portico (or both). At the peak of that effort, there were seventy workers on site. It is likely that some were slaves, as thirty-one workers put their "mark" (an X) next to their name when signing for their wages (slaves were mostly illiterate, as they were forbidden from learning how to read or write). Was this size of workforce typical for the quarry's operations, or did the size increase after John P.C. Peter built a stonecutting mill in 1837? Or, conversely, did it decrease because of productivity gains brought on by better equipment? Unfortunately, we have nothing to compare the 1823 payroll against.

The 1870 U.S. Census lists two men as "Boss in quarry": Thomas Muntz of Maryland and Alexander Giles of Ireland. They lived in the quarry master's house along with their families and boarders—a total of eight people. (James Conner is also listed as "boss at the quarry," but given the geographic layout of the census, this was likely one of the quarries upriver

such as the Government Quarry.) For the first time, quarry workers were listed in the census. All of them were men, many from Maryland, but also some from England and Ireland.

The 1880 census mentions nothing about quarry workers for a good reason: the quarry was closed during its long bankruptcy (1876–1883). Sadly, the 1890 census was destroyed in a fire, leaving a major gap in records. The final census that mentions the quarry, the 1900 census, lists only a handful of men employed as the Seneca quarry wound down its operations. As a result, we get little sense of the size of manpower or when it peaked. It is one of the many mysteries of the Seneca quarry that remain unsolved.

THE TOWN OF SENECA

Seneca is an Indian name. The town takes its name from the creek, which in turn is supposedly named after an Indian tribe in upstate New York that traveled these parts to hunt and fight its enemies. But another tradition holds that it was an Indian word for "trading place," as the Potomac was a natural trade route and Indians had been coming there for thousands of years. Old maps sometimes spell it "Sinegar."

In 1787, a surveyor named John Garrett attempted to jump-start a new town at the mouth of Seneca Creek. He called it Newport. He attempted to sell lottery tickets for five pounds that might win a purchaser a plot of land in the town, but there were few takers. Locals would later name the town Seneca after the creek that flows through it.

There isn't much that remains of the once thriving town of Seneca, a town that was born to serve the C&O Canal. It lay on the banks of Seneca Creek, stretching from River Road down to the Potomac River. It was a port in miniature, dependent on the C&O to move local farm products and freshly cut redstone to market. There were two grain warehouses just downstream from Seneca Aqueduct, both owned by the canal company but leased to local tenants. Canalboats could drop anchor at Seneca, and the canawlers often disembarked for some rest and recreation. Bob Albiol remarked, "I've been told countless times, 'When the sailors came to town, they wanted to party.'"

Seneca Mill was the town's landmark. The Tschiffely family operated this flourmill along Seneca Creek near River Road from 1900 until 1931, giving Tschiffely Mill Road its name. Seneca Mill was demolished in 1959 to make way for a new bridge on River Road.

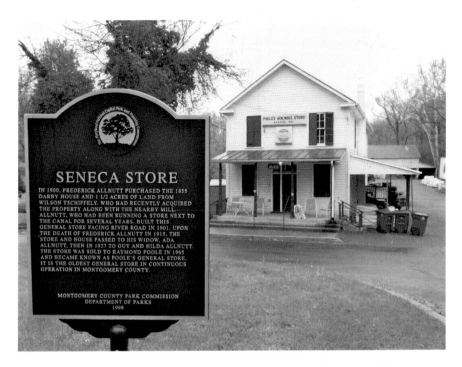

Poole's Store is one of the last surviving buildings in the once thriving town of Seneca. *Courtesy of the author.*

As the quarry and canal declined, so did the town of Seneca. When the C&O closed in 1924, the town largely died. What's left of Seneca today includes Poole's Store, the oldest general store in Montgomery County (it closed in 2011), and a tightknit African American community along Berryville Road.

THE SENECA HISTORIC DISTRICT

Beyond the immediate confines of the quarry is the Seneca Historic District, created in 1978 to preserve the historic character of the area. The most notable building is located nearly dead center of the district: Montevideo, built around 1830 by John P.C. Peter. We'll learn more about Peter in the next chapter. The Kiplinger family owns the house and surrounding farm today.

Peter built an overseer's house (also known as River View) for the Montevideo plantation manager. The house is a simple two-story Seneca

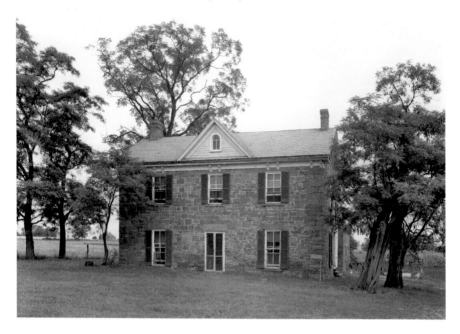

The Montevideo overseer's house, also known as River View, was built around 1835. This 1936 photo shows the house with a gable, which was removed during the twentieth century. *Courtesy of Library of Congress.*

redstone house in excellent condition, thanks to Andrea and the late John Willey, who bought the house in 1987 when they left Georgetown to raise their son Andrew there. They planted lovely gardens and a canopy of trees around the house. Near the front of the property along River Road is a large tree surrounded by a ring of cut redstone blocks that the Willeys acquired from demolished buildings. Andrea hopes to put these to use one day.

Behind the overseer's house is the slave quarters, another Seneca redstone building that probably housed the twenty or so slaves owned by John P.C. Peter. The year 1835 is neatly carved on the lintel. A wooden addition connects it directly to River View. In the twentieth century, the slave quarters became a hostel for people traveling along the C&O Canal towpath. According to Andrea Willey, its most famous guest was Supreme Court justice William O. Douglas, who loved hiking along the canal and led a well-publicized protest march in 1954 to save the canal from being paved over.

Just across River Road south of Montevideo is the Seneca School House Museum—a quaint, one-room school built around 1865. A local farmer and miller, Upton Darby, had the idea of building a subscription school to educate the many children in the community. He provided two acres of

The slave quarters behind the Montevideo overseer's house, shown in a 1936 photo. *Courtesy of Library of Congress.*

land for a whites-only school. Montgomery County ran the school from 1876 until its closure in 1910. In 1982, a local historical society, the Historic Medley District, preserved the school and turned it into a museum, now largely visited by school groups that spend a day experiencing nineteenth-century rural education.

About a mile north of Montevideo is Rocklands (14525 Montevideo Road), built by Benoni Allnutt in 1870 of Seneca redstone. The house's date is clearly inscribed, along with *B Allnutt*. The carver mistakenly carved *BAllnutt*, then attempted to fix it by inscribing another *B*. Knight Kiplinger, whose Montevideo is a superb Federal-period house, considers the Italianate house the most significant building architecturally in the Seneca Historic District. It was clearly expensive to build. The stones are smooth-cut ashlar on the front side, which is situated prominently on a hill overlooking Seneca Creek. They are rougher on the sides of the house and even rougher still on the rear, indicating that Allnutt may have found a way to reduce his construction costs.

Rocklands was likely a plantation before the Civil War. There are many buildings on the grounds, including a possible slave quarters and a simple redstone blacksmith house. Now a thirty-four-acre organic farm, Rocklands

is part of the Montgomery County Agricultural Reserve. Janis Glenn and her husband, Greg, acquired the farm in 2003. Janis joked, "We are hobby farmers." Their son, Greg, and his wife, Anna, farm the property. Greg discovered a surprising knack for farming after graduating from Virginia Tech and decided to remain on the land.

Walking through this beautiful property in the Seneca Historic District, you can't help but notice the great number of red stones that peek through the soil. Every rock reminds you of the rich history of the Seneca Valley. In fact, it's fair to say that Seneca Creek exposes us to a history that is far more ancient than we can imagine. The creek literally points the way to the quarry.

The Story of the Quarry

P resident George Washington chose the site of the nation's capital in 1791, a city that would bear his name. He hired Pierre L'Enfant to design the District of Columbia. L'Enfant grasped that the new city needed a solid supply of building materials for the stately buildings he planned. He purchased an existing quarry along the Potomac River near Aquia, Virginia—a place that became known as the Public Quarry on Government Island. The stone quarried there was Virginia freestone, a pale yellow sandstone that was used for most of the early public buildings in the capital, including the Boundary Stones, the Capitol and the White House. Sandstone is easy to carve.

But a problem soon developed: Aquia sandstone tarnishes. Much of it had to be painted over or replaced. Builders began looking elsewhere for more durable stone. They found it nearby, twenty-three miles upstream from the new capital, in a red sandstone outcropping overlooking the Potomac River. Seneca red sandstone would become a popular building material, nearly as ubiquitous as brick, for Washington buildings in much of the nineteenth century.

The first major public use for Seneca stone was the Great Falls Skirting Canal (better known as the Potowmack Canal), which the Potowmack Company opened in 1802. George Washington chartered the company in 1785 to make navigation improvements on the river. Still visible on the Virginia side of Great Falls, the mile-long canal had five locks, but it lacked the scale to carry heavy traffic. Canal builders decided they

needed something bigger—a continuous waterway for larger boats that would connect Washington to Pittsburgh. Thus was born the idea for the Chesapeake & Ohio Canal.

The C&O Canal broke ground on July 4, 1828, which was the same day as the groundbreaking for the competing Baltimore & Ohio Railroad. President John Quincy Adams and a host of delegates attended the ceremony near present-day Lock No. 6. Canals were the tried-and-true technology, and the recently opened Erie Canal in New York was (and still is) a hugely successful canal that demonstrated how canals could spur commerce. When the C&O finished construction in 1850, it joined Georgetown to Cumberland, Maryland, on a 184.5-mile watery highway. But it could never compete successfully with the B&O Railroad.

THE PETER FAMILY QUARRY

We associate the Seneca quarry with one person in particular: John Parke Custis Peter. Although the quarry had been used for at least five decades by the time he inherited the property in the 1820s, he was the first to realize its true commercial potential. But it was his grandfather, Robert Peter, who acquired the land and founded a Montgomery County dynasty that would have a strong hand in county commerce and politics for much of the next century.

Montgomery County was formally organized in 1776. It was named after General Richard Montgomery, one of the first prominent casualties of the American Revolution. Daniel Dulany the Younger (1722–1797) was a mayor of Annapolis, a Loyalist to the Crown and a major Maryland landowner. He owned much land along the Potomac River, including the stretch along Seneca Creek. In 1781, Maryland confiscated his lands and auctioned them on October 25 to help pay for the war effort. A Georgetown tobacco exporter, Robert Peter, bid on and won 2,500 acres of Dulany property. It was the beginning of his vast land purchases across Montgomery County. A tax list for 1804 showed Peter's landholdings in the county, which totaled 11,626 acres and 123 slaves.

Robert Peter (1726–1806) was born in Scotland and immigrated to the American colonies when he was twenty. He became a successful tobacco merchant operating out of Georgetown, a port dominated by his fellow Scotsmen. He was elected Georgetown's first mayor in 1791, when the town was incorporated into the new District of Columbia.

Peter married Elizabeth Scott in 1767, and together they produced eleven children—eight of whom survived. Robert purchased the entire Georgetown block bounded by Wisconsin Avenue, M Street and Thirty-first Street. This included the Old Stone House, which still stands.

Robert Peter's new property in Montgomery County, formerly part of the Dulany landholdings, included a redstone outcropping along the Potomac River. It was strange to see rock so red along this jagged escarpment abruptly exposed by the Potomac, and it extended about three-quarters of a mile west of Seneca Creek. An intermittent stream called Bull Run paralleled Seneca Creek a quarter mile to the west, exposing a rift of red sandstone deep into the cliff side.

It isn't known exactly when European settlers first started quarrying redstone at Bull Run. Some would have it as early as the 1760s, shortly before the American Revolution, but it may have come as late as the 1790s, when Robert Peter allowed the Potowmack Company to quarry stone for the Potowmack Canal. In any case, the quarry produced sturdy stone of remarkable color, and locals built their houses from redstone quarried on the Peter property.

When Robert Peter died in 1806, his children divided his vast holdings, but not evenly (one son was an alcoholic, so Peter left him only twenty pounds). Two of the sons who are most important for our story—the eldest son, Thomas, and the second-to-youngest son, George—each began building homes for their growing families. Thomas built Tudor Place in Georgetown, while Robert built Montanverde as a summer residence in Seneca, though he would later live there year-round.

George Peter (1779–1861) was born in Georgetown just two years before his father acquired the Dulany holdings. George had a rather storied career. He served in the army and later testified against Aaron Burr, fought as a major in the War of 1812, was elected to Congress in 1815 and served in the Maryland House of Delegates. He built a summer house, which he named Montanverde after a French officer, east of Seneca Creek between 1806 and 1812. In 1837, he made Montanverde (14601 Berryville Road) his permanent residence. George married three times and had sixteen children, and he was the county's largest slaveholder, with more than one hundred slaves.

Though a slaveholder and Democrat, George Peter hosted Congressman Abraham Lincoln in 1848 for a political rally, and Lincoln stayed overnight at Montanverde. George died in 1861 and is buried at Georgetown's Oak Hill Cemetery. One of his sons, also named George (1829–1893), was an

attorney who served as a Maryland state senator and was involved in the Seneca Sandstone Company after the Civil War.

Robert and Elizabeth Peter's first son, Thomas (1769–1834), inherited the largest share of property in Georgetown and Montgomery County, including the rich farmland and quarry near Seneca. In 1795, Thomas married Martha Custis Peter (1777–1854), the granddaughter of Martha Washington, George Washington's wife. His father, Robert, gave the couple one of the six houses that he owned east of Rock Creek at 2618 K Street NW. (The house was torn down in 1961.) Like his father, Thomas became mayor of Georgetown and was a successful tobacco exporter.

In 1805, Thomas and Martha Peter hired William Thornton, the first architect for the U.S. Capitol, to construct a Federal-style mansion for them in Georgetown. Tudor Place (1644 Thirty-first Street NW) took eleven years to build. It was completed in 1816, a year after the War of 1812 ended. The house is built of brick covered in stucco, not Seneca sandstone. The Marquis de Lafayette visited the mansion during his 1824 tour of the United States. Four generations of Peters resided in Tudor Place, which remained in the

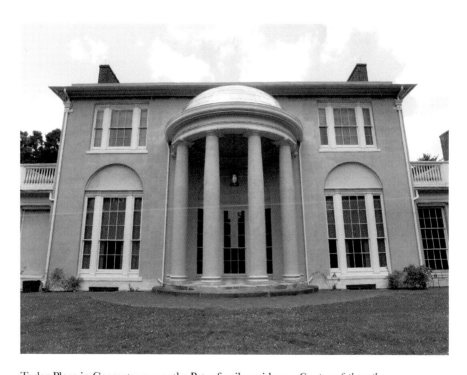

Tudor Place in Georgetown was the Peter family residence. *Courtesy of the author.*

family until 1983, when it was left to a foundation that opened the house to the public in 1988.

Part of Thomas Peter's inheritance included the redstone quarry on Bull Run. The quarry continued to be used on a small scale, often just for local building materials in the Seneca area. In the 1820s, a small amount of Seneca stone made it into the White House, where the north and south porticoes are constructed of redstone, and the U.S. Capitol, where two doorways to the Rotunda and adjacent flooring are made of sandstone. Thomas Peter also built a summer residence called Oakland on his property near Partnership Road, west of Seneca. No trace of it exists today.

Thomas and Martha Peter had eight children, including three daughters: America, Britannia and Columbia. Their third child and eldest son was born on November 14, 1799. They named him John Parke Custis Peter.

As John P.C. Peter came of age, he developed a liking for the country, which he preferred over the more cosmopolitan Georgetown or Annapolis. (John served in the Maryland House of Delegates from 1826 to 1828.) His father conveyed land around Seneca to his son, and John began building a rural residence in 1828, a small replica of Tudor Place. The Federal-style house took two years to build. Peter named it Montevideo (from the Latin *montem video*, or "I see the mountain") for its splendid view of Sugarloaf Mountain to the north.

Montevideo (16801 River Road) was built from Seneca red sandstone quarried on the Peters's property. The exterior was covered with stucco, but you can see the redstone in the belt course of the raised basement. The two-story house was built on high ground a half mile west of Seneca Creek and is fancier than most country houses in the area. The house sent a clear message: John P.C. Peter was a country gentleman.

John P.C. Peter married Elizabeth Jane Henderson (1812–1877) at his uncle George's house, Montanverde, in February 1830, when John was thirty years old and Jane was seventeen. They moved into Montevideo later that year. She bore him nine children in the eighteen years of their marriage, all but one surviving beyond infancy. The children were Sarah, Thomas, John P.C., Martha, James, Jane, Britannia and Daniel. The Peter family was nothing if not prolific. Jane had two more children with her second husband, the Reverend Charles Nourse.

Montevideo was a plantation, and John P.C. Peter owned more than twenty slaves. No sooner had he and his wife moved into their new home when three slaves escaped. On July 20, 1831, John began running an advertisement in the *Daily National Intelligencer* offering a reward of up to $150 for their

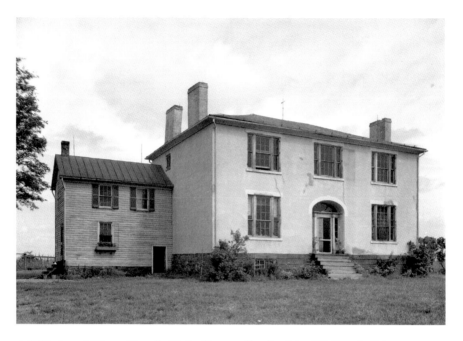

A 1936 view of Montevideo, the Tudor Place replica that John P.C. Peter built between 1828 and 1830. *Courtesy of Library of Congress.*

apprehension and return. The escaped slaves were the brothers Peter and George Boman and a third named Beverly Davis. "They all absconded at the same time, without the smallest provocation, and have, no doubt, gone in the direction of Pennsylvania," Peter wrote.

Peter owned about a half mile of Potomac shoreline west of Seneca Creek. The C&O Canal Company intended to dig the canal right through his property and surveyed the route in 1827. The canal had the power of eminent domain on its side, but property owners could challenge the land condemnations if they didn't think they were getting fair market value.

In the hope of getting a larger settlement, Peter disputed the land condemnation in court in April 1829. A jury awarded him $2,199.34. This was too little for Peter, who demanded greater compensation, but the canal's board refused. The parties went back to court in January 1830. Peter was once again offered the same amount, but he rejected the offer. A second jury was drawn up in May, and this time Peter's award was revised slightly downward to $2,143.00. Realizing that he wasn't going to win greater compensation, and with growing legal bills from the extensive court process and negotiations, Peter agreed to settle.

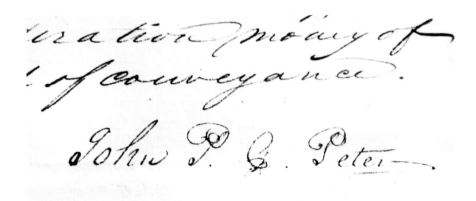

John P.C. Peter's signature on the June 25, 1830 deed conveying his Potomac shoreline property to the C&O Canal, adjacent to the Seneca quarry. *Courtesy of National Archives and Records Administration.*

The C&O threw in a major incentive. In addition to paying for the narrow strip of land along the Potomac, the canal company offered to pay Peter for the right to dig twenty thousand cubic yards of earth and to quarry 5,500 perches (cubic feet) of redstone from Peter's property to build the canal. They agreed to a purchase price of $0.25 per perch, potentially worth up to $1,375.00. Peter signed the deed on June 25, 1830—twice, in fact—once to convey the property and again to acknowledge the receipt of payment. His wife witnessed the deed with her signature. The deed now resides in the National Archives in College Park, Maryland, where the C&O Canal records are stored.

As the workers dug the first stretch of the canal from 1828 to 1830, rock from Peter's quarry was floated down the Potomac. Seneca red sandstone was used beginning at Lock No. 8 (the start of "Seven Locks," just downstream from the American Legion Bridge) and was used for locks 9, 11, 15–27 and 30, as well as most of the accompanying lockhouses.

The C&O Canal Company built Dam No. 2, a 2,500-foot rubble dam, just above Seneca Falls near Rowser's Ford. (Seneca Falls begins a half mile downriver from Seneca. It's not a true waterfall but rather a series of rocky cascades in the Potomac.) With this in place, water was drawn in through the guard/inlet lock and "watered" the canal downriver. The C&O opened navigation up to Lock No. 23 in 1831. With John P.C. Peter's settlement in hand, it could now continue construction toward Harpers Ferry.

Two packet boats, the *Charles Fenton Mercer* and *George Washington,* began making daily trips between Georgetown and Seneca. It was now easy and

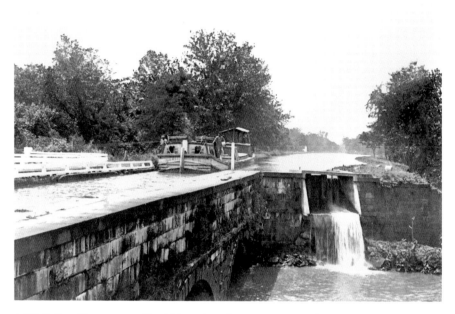

A C&O Canal boat manned by African Americans traverses the Seneca Aqueduct. Behind it is the turning basin, and beyond to the right is the Seneca quarry. *Courtesy of C&O Canal National Historical Park.*

comfortable to return to the city without riding on bumpy, unpaved roads. This made the Peters's country life considerably better.

The C&O soon began constructing the three-arched redstone aqueduct crossing Seneca Creek, the turning and loading basin and the canal bed westward. The twenty thousand cubic yards of soil removed from the Peter property, as stipulated in the settlement, could have only been for the turning basin, which lapped at the base of the quarry and made it convenient for Peter to ship his sandstone. Now he had a harbor right at his doorstep, its retaining walls built with stone from his quarry (as was the nearby redstone culvert for Bull Run).

Aqueduct No. 1, better known as Seneca Aqueduct, was begun in 1829 and completed in 1832. A unique structure on the C&O Canal, Seneca Aqueduct is the only aqueduct that is also a lock (Lock No. 24, also known as Riley's Lock; it is named after John Riley, who ran the lock from 1892 until the canal closed in 1924). Seneca Aqueduct is doubly unique in that it is the only aqueduct made of Seneca redstone. The adjacent lockkeeper's house was finished in 1830.

In 1833, Dam No. 3 opened, watering the C&O Canal between Harpers Ferry and Seneca. From that moment on, John P.C. Peter could ship redstone directly to Washington via the canal. The C&O provided a considerable opportunity for the Peters. John was a young man from a wealthy family with a new wife and a prestigious new home. He may have initially begrudged the C&O cutting through his property, but he soon realized that the canal was a ready-made highway to get his stone to market—he even had a harbor to load boats with stone. Peter began ramping up production at the quarry. At some point, perhaps as early as 1830, he built the quarry master's house.

In 1837, Peter sold 5,400 square feet of stone for flagging (walkways) and stairs for the Treasury Department. That same year, he was so won over by the quarrying opportunity that he purchased the adjacent property to the west from Clement Smith. This included a quarry just above the C&O, less than a mile from Seneca.

Peter was much more than a quarry operator. He had been a Maryland state legislator while still in his twenties, and he saw himself primarily as a gentleman farmer. Peter championed agricultural improvements such as crop rotation. He helped organize the Montgomery County Agricultural Society in 1844 and became its first president. He also served on the school board in nearby Darnestown.

But John P.C. Peter's life was cut short. He contracted lockjaw (tetanus) from a rusty nail scratch to the thumb and died at Montevideo on January 19, 1848. At the time, his quarry was piled high with stone blocks cut for the Smithsonian Castle, waiting for the spring thaw to reopen the C&O Canal.

Peter was buried in the family cemetery on the Montevideo farm, north of the house, and surrounded by a wrought-iron fence. His grave is marked with a red sandstone obelisk that identifies him as the great-grandson of Martha Custis Washington. (Someone later used it for target practice, as there are bullet pockmarks.) Other family members are also buried there under flat redstone ledger stones: John P.C. Peter's parents, Thomas and Martha, and an older sister, Columbia. There is also a stone for an infant. Two Kiplingers are buried next to the Peter family cemetery, but we are getting ahead of ourselves.

It isn't clear who took over management of the Seneca quarry after Peter died. None of the children was old enough to assume responsibility for the property, which went into a trust. But the quarry continued operating. Gilbert Cameron, the contractor building the Smithsonian Castle, wouldn't complete the building until 1852. Until then, the Peter family was assured a steady stream of income.

The Story of the Quarry

In March 1849, about a year after John P.C. Peter's death, his widow, Jane, married her children's former tutor, the Reverend Charles Nourse. This caused a scandal, as the family thought she had remarried too soon. According to lore, Jane's mother-in-law, Martha Custis Peter, shut off communications with Jane and refused to set eyes on Montevideo again—though Martha was buried in the Montevideo family cemetery after her death in 1854. That same year, Charles and Jane Nourse and their combined households of up to ten children (Nourse had a son from his first marriage, and they had two children of their own) moved to Virginia, settling in the Leesburg house that would become the home of General George Marshall in the mid-twentieth century.

We don't know why Charles Nourse moved the family to Virginia. Perhaps it was a business opportunity, as he opened a boarding school in Leesburg and served as headmaster of another. Or perhaps there was a family feud with the estranged members who disapproved of the marriage. Or maybe there was a conflict over the trust (the eldest child, Sarah, sued the estate in 1858 over the division of property). But one scenario seems likeliest of all—the oldest son, Thomas Peter, would soon turn twenty-one and would inherit the property.

We find Thomas Peter in the 1860 U.S. Census, age twenty-six, living at Montevideo with his wife, Elizabeth, and their two infant sons. As the person responsible for managing the family trust, Thomas had to maintain the Seneca farm and oversee the quarries. The trust John P.C. Peter had established for his children was to end in 1868, after which the property would be divided among them. However, the Civil War intervened and cost the Peter family dearly. The Union occupation of Maryland, Confederate attacks, the loss of their slaves (Maryland abolished slavery in 1864) and the closure of the quarry during the four-year hostilities brought on hard economic times.

After the war ended, in 1866, Thomas Peter sold the quarry and 614 acres of his riverfront property to the newly formed Seneca Sandstone Company for $70,000—a substantial sum in that era. Ten years later, the Peters sold off Montevideo, coincidentally the same year as the quarry's bankruptcy sale.

THE GEOLOGY OF SENECA REDSTONE

How did this unique outcropping of red sandstone come to be? Joe Smoot, a geologist at the U.S. Geological Survey, provided the answer. He explained that sedimentary sandstone began to form about 230 million years ago in the Triassic age. The continents had united into a super continent, Pangaea, and had pushed up the Appalachian Mountains to the west but were now pulling apart, creating rift basins. This particular rift is known as the Culpeper Basin.

The climate was arid, and there were enormous desert flats, much like the Mojave Desert, but even larger. A river—an ancient ancestor to the Potomac—meandered across the basin. Over the next thirty million years, the basin slowly filled with alluvial (river) deposits, which eventually condensed into sandstone. The Culpeper Basin extended from Frederick, Maryland, to about forty miles south of Manassas, Virginia, thus giving the stone its name: Manassas sandstone. That ancient river deposited sand that became the Seneca quarry.

So how did the sandstone turn red? "The red is very complicated, it turns out," Smoot said, noting the importance of the once-arid climate. "The red color is a mineral reaction that occurred long after the sand was deposited. The sand was loaded up with minerals that, in a wet environment, would weather into clay." But in a dry environment, these iron-rich deposits were absorbed into the sandstone with the intermittent groundwater. "Over the period of tens of thousands of years, it will break down and turn into hematite, which is iron oxide," Smoot adds. "Basically, the rock is red because it is rusty."

If you walk into the Seneca quarry, you see a plethora of red sandstone towering over you, just waiting to be mined. Might geology have something to do with the quarry shutting down? Indeed. "They were quarrying out the channel," Smoot explained. "What we see now are the edges of the channel, not the thickest, deepest parts." Along the ancient riverbanks, sand piled on in thin, shifting layers, where ancient trees rooted and shrimp burrowed, rather than condensed blocks. By the 1890s, stonecutters had used up much of the best stone and were now quarrying layered sandstone that flaked. The quality of the sandstone diminished enough that the last owner, George Mann, closed the quarry in 1901, even though there is much sandstone still left.

There were numerous quarries along the one-mile stretch of the Potomac west of Seneca Creek. Just a quarter mile west of John P.C. Peter's Bull Run quarry was the College quarry, so named because it provided the grey-blue

sandstone for Georgetown University. Peter operated another quarry about one thousand feet west of the College quarry, and a half mile to the north was Lee's quarry (later known as the U.S. Government Quarry). A road once connected these latter two quarries and the cemetery to River Road; it is now a barely visible forest track. Alfred Mullett, architect of the State, War and Navy Building (now the Old Executive Office Building) next to the White House, described the stone in 1874 Congressional testimony: "The vein becomes grayer as you go up stream, and as you come down it is redder, but it is identically the same stone."

The Smithsonian Castle

A most unusual thing happened in 1835: the United States government was informed that it had been given a significant bequest by a British citizen who had died six years earlier in Genoa, Italy. Few Americans had ever heard of the donor, save a handful in the scientific community. The man was James Smithson.

Smithson was a wealthy chemist who never married. His will directed that his bequest be given "to the United States of America, to found at Washington, under the name of the Smithsonian Institution, an Establishment for the increase and diffusion of knowledge among men." There were no other instructions—he left it to the Americans to interpret how to execute his vision. The bequest gave rise not only to the Smithsonian Institution Building, better known as the Smithsonian Castle, but also to nineteen galleries and museums that occupy much of the National Mall in Washington, D.C., as well as the National Zoo.

James Smithson is little known to most Americans, as his papers were destroyed in the 1865 fire at the Smithsonian Castle. Smithson's biographer, Heather Ewing, described him in *The Lost World of James Smithson* as "a man with an insatiable curiosity, the illegitimate son of the Duke of Northumberland, elected at a mere twenty-two to England's oldest and most prestigious scientific society, who left his entire fortune to a country he had never visited." Smithson was an admirer of the United States and its democratic system of government.

In 1836, President Andrew Jackson dispatched Richard Rush to England to secure the Smithson bequest. Rush was the son of Benjamin

Rush, Founding Father, Declaration of Independence signer and surgeon to the Continental army during the American Revolution. The younger Rush had an exceptionally distinguished public service career, serving in the administrations of James Madison, James Monroe and John Quincy Adams. He had also been a treasury secretary and minister to England. As the country's agent for the Smithson bequest, Rush steered the case through

Congressman Robert Dale Owen pushed the Smithsonian bill through Congress in 1846, became one of the first members of the Smithsonian Board of Regents and was on the building committee that selected architect James Renwick for the castle design. *Courtesy of Smithsonian Institution Archives. Image #2002-12184.*

the Court of Chancery in less than two years. He took possession of 104,960 gold sovereigns, so called because they had the face of the British monarch on them—in this case, the newly crowned Queen Victoria.

Rush shipped the sovereigns to the United States, where they were melted down and recast so American banks would accept them. Two of them are preserved in the National Museum of American History. The U.S. Department of Treasury deposited the Smithson bequest—$508,318—on September 1, 1838. It would take eight years for the federal government to decide how to spend this unusual windfall. In the meantime, the money sat in the bank earning interest.

The 1840s were anxiety-filled years, as the question of slavery pressed on everyone's minds. Partisan gridlock made it difficult to get anything done in Washington. The Mexican-American War (1846–1848) made it worse, as hawkish southerners demanded the annexation of vast parts of Mexico, which they hoped to open to slavery. Southerners were especially suspicious of creating a national institution like the Smithsonian, as it represented a consolidation of power at the expense of the states—and states' rights were a code word for the protection of slavery.

It was a minor miracle then that Congress finally addressed the question of the James Smithson bequest. Indiana congressman Robert Dale Owen helped push the law through—and this while American forces were fighting the Mexican army in 1846. The bill stipulated that a board of regents would oversee the institution. This included the vice president of the United States, the chief justice of the Supreme Court, three senators, three congressmen and nine private citizens (usually chosen for their philanthropy). Thus, the Smithsonian's governance and financial support was both private and public from the beginning. Among the first regents were Richard Rush, who had fought so hard for the Smithson bequest, and Robert Dale Owen.

The Architect

The board of regents of the Smithsonian Institution got to work in September 1846. One of their first responsibilities was to solicit architectural proposals for the Smithsonian Institution Building, a task they took up just two days after their first meeting.

Robert Dale Owen and Robert Mills drafted the requirements for the building. They wanted a medieval revival structure, a multipurpose facility

with collection and exhibition space, laboratories, lecture rooms, libraries, living quarters and offices. The building committee (Robert Dale Owen, Washington mayor William Seaton, George Dallas, William Hough and Joseph Totten) issued a public invitation for proposals and then traveled to the Northeast to drum up interest. Architects had until December 25, 1846, to submit their designs.

Nearly a month before the deadline, the building committee announced on November 30 that it had a winner, to great consternation from the competing architects. James Renwick Jr. was chosen as the architect for the Smithsonian Institution Building, as recorded in the committee minutes:

> *The committee unanimously selected, out of thirteen plans, that were submitted to them by some of the principal architects throughout the country, two by Mr. James Renwick, Jr., of the city of New York, the architect of Grace Church, the Church of the Puritans, Calvary Church, and other structures, in and near New York; and they recommended to the Board for adoption one of these, being a design in the later Norman, or, as it may, with more strict propriety, be called, the Lombard style, as it prevailed in Germany, Normandy, and in Southern Europe, in the twelfth century.*

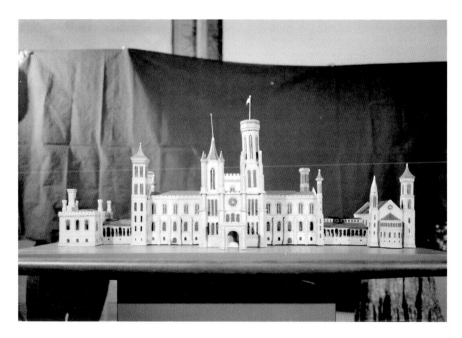

James Renwick's original architect's model for the Smithsonian Castle. He called for three floors, though only two were built. *Courtesy of Library of Congress.*

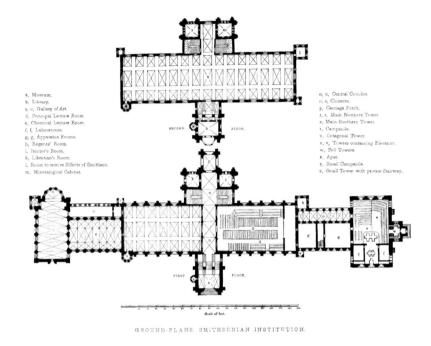

a, Museum.
b, Library.
c, c, Gallery of Art.
d, Principal Lecture Room.
e, Chemical Lecture Room.
f, f, Laboratories.
g, g, Apparatus Rooms.
h, Regents' Room.
i, Janitor's Room.
k, Librarian's Room.
l, Room to receive Effects of Smithson.
m, Mineralogical Cabinet

n, n, Central Corridor.
o, o, Cloisters.
p, Carriage Porch.
r, r, Main Northern Tower.
s, Main Southern Tower.
t, Campanile.
u, Octagonal Tower.
v, v, Towers containing Elevators.
w, Bell Towers.
x, Apse.
y, Small Campanile.
z, Small Tower with private Stairway.

GROUND-PLANS, SMITHSONIAN INSTITUTION.

James Renwick's floor plans for the Smithsonian Castle were reproduced in Robert Dale Owen's 1849 book *Hints on Public Architecture. Courtesy of Library of Congress.*

James Renwick Jr. was a prodigy. He was only twenty-eight years old but already a successful architect with a thriving practice. As a self-taught architect, he had won the competition to design Grace Church in New York in 1843, a Gothic Revival church that launched his career. He later designed St. Patrick's Cathedral in New York and the Corcoran Gallery of Art (now the Renwick Gallery) in Washington. For the Smithsonian competition, Renwick submitted two designs—one Gothic, the other Romanesque. The building committee, especially Robert Dale Owen, fell in love with the Romanesque design. It evoked a university, a center for knowledge and learning. And as we'll see, the Gothic proposal became the inspiration for Trinity Episcopal Church.

The regents soon picked the location of the new building on the National Mall. On December 3, three days after picking Renwick's design, the board selected the first secretary of the Smithsonian: Joseph Henry, a professor at Princeton University, who would serve until 1878. Henry actually objected to the construction of such a large building, believing instead that the Smithsonian should spend the money on research. Nevertheless, Henry and his family would take up residence in the castle's east wing.

Choosing Seneca Redstone

The nation's capital in 1846 was still a small town with just a handful of public buildings, mostly built with white sandstone from the Aquia quarry in Stafford County, Virginia. The main public buildings were the Capitol, Patent Office (now the National Portrait Gallery and Smithsonian American Art Museum), Post Office (now the Hotel Monaco), the Treasury Department and White House.

The Smithsonian Building Committee opened the bidding to quarries that wished to supply stone for the Smithsonian Castle. Fifteen quarries bid on the project, and all fifteen submitted stone samples for scientific testing. Robert Dale Owen hired one of the country's preeminent geologists, his own brother, Dr. David Dale Owen, to examine the various quarries.

The committee ruled out the Aquia quarry. Although the quarry offered a low price (forty cents per perch or square foot), it was widely known that the stone was inferior. "That the Aquia creek freestone, heretofore used in public buildings in Washington, is a material not to be trusted to, being pervaded by dark specks of the protoxide and peroxide of iron, which, in peroxidating, acquire a yellowish or reddish color, and having occasional clay holes, such as disfigure the Treasury and the Patent Office," the committee reported. Official Washington was already shifting to better building materials.

One bid stood out from the others, both for its distinct color and its astonishingly low price: John P.C. Peter's quarry at Seneca, which the building committee consistently referred to as the Bull Run quarry. The committee hinted toward its decision by reporting, "That the freestone [sandstone] of the upper Potomac, in the vicinity of Seneca creek, and found in quarries close to the line of the Chesapeake and Ohio canal, is the best and most durable of all the Potomac freestones."

The building committee noted the quotes it had received per perch from the various quarries: granite went for forty-six cents, while fine-grained marble started at seventy cents. And then there was John P.C. Peter's bid of twenty-five cents per perch, which was far below the market rate. Peter explained his bid in a letter dated December 9, 1846: "The jury, in condemning the quarries for the use of the canal company, allowed me twenty-five cents a perch for the backings; that is, all stone intended for cut work, twenty-five cents—all calculated for hammered work, twelve and a half cents a perch; and for those prices would I grant permission to obtain stone for any purpose." (The jury he referred to was from his 1830 lawsuit against the C&O Canal over the right-of-way through his

property.) Another project had recently come along, and Peter offered the contractor, a Mr. Berry, twenty cents per perch—a 20 percent price cut from his C&O settlement.

The year was now 1847, but Peter was still quoting the 1830 price. He had significantly underbid the market (the closest was the inferior Aquia sandstone at forty cents a perch). Considering that inflation had probably doubled prices by then, Peter could have bid fifty cents per perch and still had a competitive bid. So why did Peter bid so low? Did he not understand his quarry's value, or did he feel legally bound to offer that price based on the 1830 settlement? The evidence is contradictory. Perhaps Peter made a shrewd decision to capture the market by underbidding the other quarries.

Peter's offer was too good for the building committee to pass up, and on March 18, 1847, it accepted his offer. Peter wrote back four days later, confirming the price at 25 cents per perch for cut stone (ashlar) and 12.5 cents for rubble. (The committee's summary report for 1847 mentioned that it paid 20 cents for Seneca redstone, which was either a typo or the committee negotiated the price down another 20 percent from an already astonishingly low offer. The committee's minutes don't reflect any such negotiation.)

A week before the building committee awarded the quarry contract, James Renwick and Dr. Owen visited Seneca on March 11, and each filed a report that helped seal the deal. The committee summarized, "The lilac-gray variety found in the Bull Run quarry, twenty-three miles from Washington, was especially recommended." John P.C. Peter accompanied them. They started at Peter's Bull Run quarry, which Owen noted "have hitherto been carried on from 250 to 300 yards on the north side of the canal," and spied the obvious advantage of having the C&O Canal immediately accessible.

The geologist Owen noted the varying colors of stone that came from this mile-long stretch of Potomac shoreline. "These deposits are of various colors, from a light, greenish-gray, or dove-color, to a deep red or brown," he wrote. He observed that the purplish-grey rock "is the rock most suitable for building purposes, its color being agreeable, and, in the opinion of men of good judgment and taste, appropriate for the Norman style of architecture." He added, "When first removed from the parent bed, it is comparatively soft, working freely before the chisel and hammer, and can even be cut with a knife; by exposure, it gradually indurates, and ultimately acquires a toughness and consistency that not only enables it to resist atmospheric vicissitudes, but even the most severe mechanical wear and tear." The building committee repeated this statement nearly verbatim in its 1847 report.

A quarter mile west of Peter's Bull Run quarry was the College quarry. Owen noted that it was on a "bold escarpment of 20 or 30 feet in height, close to the margin of the canal." Between the Bull Run and College quarries, Owen observed that the hillsides had been quarried in numerous places and yielded redstone. A few hundred yards west of the College quarry was yet another quarry that Peter had acquired in 1837—one that provided grey sandstone. All of these fronted on the C&O Canal. They visited yet another quarry, owned by a Mr. Lee, a half mile inland and to the north that provided "warm gray" stone. The federal government would acquire this quarry, which became known as the Government Quarry, in the 1850s for projects such as Washington Aqueduct.

Renwick approved of the Bull Run quarry. "The stone is of excellent quality, of even color, being of a warm gray, a lilac tint resembling that known as ashes of roses, and can, from all indications, be found in sufficient quantities to supply all the face work for the Institution," he reported to the building committee. He also noted that the quarry itself was in the Bull Run channel, meaning that the stone for the Smithsonian Castle was literally quarried around Bull Run, not from the cliffs that we see to the east along the C&O Canal turning basin (those were probably quarried after the Civil War as the quarry operations expanded). Thus, we can fairly pinpoint where the redstone for the castle came from.

Both Renwick and Dr. Owen took note of Peter's barn or stable at his nearby home, Montevideo. Owen wrote, "Mr. Peter, on whose property this quarry is situated, has built a fine barn of these freestones. He assures me that there are stones in that barn 50 years old, which have been in three buildings. On one cornerstone, where the figures '1824' had been cut in that year by the point of a penknife, the rock now is so hard that it would soon turn the edge of a well-tempered tool."

Renwick likewise wrote: "In company with Mr. Peter, we next visited a house built of coursed and hammered rubble masonry of stone of this color, in which it had a pleasing and airy effect upon the eye," which was most likely the overseer's house. He added, "Mr. Peter's stable is also built of stone of this color, and produces an excellent effect." This was the Greek Revival barn that stood near the overseer's house—a building that Eugenia Pierpoint would demolish in 1975.

Renwick and Owen each indicated that they were attaching sketches of the Seneca quarries, which would have been an archivist's dream. These maps were not printed in the building committee records; sadly, it seems they were lost to the 1865 fire at the castle.

The building committee then took bids from contractors to build the castle. It received fourteen bids ranging from $196,000 to $318,000. James Dixon & Co. bid $228,500 for marble ashlar but $205,750 for Seneca ashlar. (Dixon estimated the stonecutting portion of the bid at $80,000, meaning that the rock would be more than a third of the total cost.) The committee accepted Dixon's lower offer and issued a contract on March 20, two days after accepting Peter's offer. The actual contractor would be Gilbert Cameron, a partner in the firm. The contract stipulated: "The building shall be faced, and all the cut-stone work dressed from the best Seneca freestone from the upper Potomac, to be taken from the Bull Run quarry, or some other quarry in the neighborhood of Seneca creek…and free from all imperfections."

James Dixon visited Peter's quarry on April 6, 1847, and he didn't like what he saw. He wrote the building committee, "After minute examination of all the quarries on Mr. Peter's land, it is extremely doubtful to me whether or not a sufficient quantity of the stone on which the contract is based can be procured in any of his quarries, as that stratum seems to be nearly exhausted."

Suspecting trouble, Peter immediately wrote the committee, saying that Dixon only made a "superficial examination of the quarries" and claiming that there was enough stone. "I would only add that the kind of stone that I understand you have selected may be obtained here in any quantity you may require, and the difference in the expense of using it is a full justification for its selection," he wrote. Fearing that he would lose the contract, Peter traveled to Washington to meet with the building committee and Dixon on April 16. The committee elected to stick with Peter's quarry and the stone it had chosen. Dixon resigned as contractor on June 1, leaving Gilbert Cameron to execute the project himself.

One of Cameron's responsibilities was handling the stone at the Bull Run quarry, ensuring it was properly cut for the building and transporting it via the C&O Canal to the building site. This was a significant expense. Robert Dale Owen did his best to win a reduction in the transportation rate on the C&O Canal. He wrote the canal president, J.M. Coale, asking for a lower rate by leveraging the offer from the railroads that had bid in support of Maryland quarries: "The Maryland railroad companies had agreed, in event of our selecting marble, to reduce their rates of freight, in our favor, from 4 cents to 2½ cents per ton per mile."

Coale wrote back, noting that the stone already had a very low rate (although not directly comparable, as the rate was based on perch rather

than ton): "I would here, however, merely remark, that the toll charged on stone at present on the canal is 1 cent per perch per mile for twenty miles, and 1½ cent per perch per mile for any greater distance it may be carried." He believed this would still be lower than the railroads, although given that the quarry was twenty-three miles from Georgetown, the C&O could levy a nice surcharge for the last three miles. One wonders if the C&O Canal established its pricing with Peter's quarry in mind. Coale later wrote Owen again, confirming that the C&O board had rejected a reduction in rates.

BUILDING THE CASTLE

The cornerstone for the Smithsonian Institution Building was laid on May 1, 1847. Some three thousand people attended the festivities. It was a grand fanfare that included a great number of Freemasons who turned out in their aprons and gloves. They paraded to the White House and then to the building site. Most Worshipful Grand Master Benjamin French began the ceremony by explaining that he was wearing the apron that George Washington wore when he broke ground for the Capitol. The *Baltimore Sun*'s correspondent, under the pen name Mercury, reported, "The Masonic craft then proceeded, and in the ancient and peculiar mode prescribed by the Masonic chart, laid the corner stone of the Masonic Institution." A metal plate was placed under the stone, engraved with the names of President James Polk, the board of regents, the officers of the institution, the secretary, the assistant secretary, the architect, the assistant architect and the contractors, James Dixon and Gilbert Cameron.

U.S. Vice President and Board of Regents member George Dallas then delivered a thirty-two-minute address. President Polk was apparently busy that day, leading the nation in its war against Mexico. He stated, as recorded in the *Baltimore Sun*, "Already it has added to her social scene a fixed star whose beams pervade the scientific world; and ere long, this rising temple, consecrated to the highest of human pursuits, *knowledge,* will give fresh attraction and firmness to her destiny."

The formalities concluded, and Cameron started work on the east wing. As one crew prepared the site on the mall, another began cutting, shaping and polishing the stone at the Seneca quarry.

We find in the C&O Canal toll records that the first boat from Seneca, *Scow No. 1*, carrying thirty-five perches of "rough stone" for the castle, passed

through Georgetown on June 12, 1847. It paid $8.58 in tolls. Two days later, the next boat brought twenty-two perches and paid $5.72. These boats continued past Georgetown along the Washington Branch Canal through Foggy Bottom to the Washington City Canal that traversed the north side of the mall. (The City Canal is now Constitution Avenue; it was filled in in 1870. The only remnant left is the lockhouse at Seventeenth Street, though stonework was also uncovered during the excavation for the National Museum of African American History and Culture.) Canalboats carried the stone from the quarry virtually to the doorstep of the Smithsonian construction site. The building committee never reported how many perches of Seneca sandstone the castle used or how much John P.C. Peter was paid. Presumably, this was Gilbert Cameron's affair.

"We always get the question: 'Did slaves build the Castle?'" noted Smithsonian Castle curator Rick Stamm. The truth is, we don't know. Certainly, John P.C. Peter may have rented his slaves to Cameron at the quarry, but we know nothing about the workers who actually built the castle. Slaves were involved in building most public buildings in the early years of Washington, but by the 1840s, there was a growing contingent of Irish immigrant workers who could be employed at low cost.

In October 1847, a Potomac freshet (flood) knocked out the C&O Canal for several weeks. The building committee observed that Cameron "has now some twelve or fifteen thousand feet of stone lying ready quarried, and waiting the re-opening of the canal." This would be the first of many disruptions to the quarry operations over the next five decades.

The C&O Canal wasn't a year-round operation but rather closed for winter in December and usually reopened in March. During the winter closure, the canal would conduct necessary maintenance and repairs. Cameron's team could cut and stockpile stone while they waited for the canal to reopen. In the middle of winter, the unthinkable happened—Seneca quarry owner John P.C. Peter contracted tetanus and died at Montevideo on January 19, 1848. He never got to see the Smithsonian Castle.

As the castle's east wing took shape, Cameron commenced work on the west wing. By 1850, he began constructing the large central portion of the building, which includes the distinctive north and south towers that most people recognize when they think of the Smithsonian Castle. The north tower has two parallel towers: one, shorter and square shaped, the other taller with an octagonal crown and known as the bell, clock or flag tower.

Later that year, part of the lower main hall collapsed from shoddy interior wooden materials. The building committee worked with architect James

Renwick to correct these issues and make the castle more fireproof. This added $44,000 to the price tag. That same year, the C&O Canal was closed again for four months, putting a major delay on castle construction.

Renwick continued to live in New York but came down to Washington monthly to check on progress. He was paid $1,800 per year for the life of the project. His original design called for three main floors, but in order to cut costs, only two were actually built. As Renwick was essentially a consultant to the project, the building committee chose Robert Mills as the assistant architect to handle the day-to-day building decisions.

In 1849, Robert Dale Owen published his book *Hints on Public Architecture* to make the intellectual case for the architectural choice of the Smithsonian Castle. It was a book that examined public architecture throughout history. It included illustrations of architectural features, including many of the Smithsonian Castle. The final illustration was a James Renwick drawing of a four-pillared gate south of the castle that wouldn't be built until the 1980s.

The board of regents declared that the exterior of the building was essentially complete in 1852 and that Renwick's services were no longer needed. Renwick's five years on the project came to an end. The castle still had a number of areas to finish, including the fireproofing and lecture hall, so the regents hired Barton Alexander to wrap up the project. Gilbert Cameron continued as the contractor.

In the Smithsonian Castle, James Renwick put his indelible stamp on Washington architecture. The genius of his design joined classical ideas of discovery and learning with its twelfth-century Romanesque style and distinctly American eclecticism. Architectural styles like Gothic and Baroque stressed order and uniformity, but there is a freehand quality to Romanesque. Nothing needs to be uniform. The castle is completely asymmetrical—the front and back don't match, nor do the east and west wings or any of the towers. Nine towers grace the castle, and no two are exactly alike.

The castle is a stand-alone masterpiece, but equally important is the influence it had on a half century of Washington architecture. Coming at the end of the Greek Revival period that dominated American architecture from the 1820s until the 1840s, the castle marks the beginning of Victorian architecture in the nation's capital, a period that lasted five decades until 1900. Local architects such as Adolf Cluss and T. Franklin Schneider would design thousands of Gothic, Italianate and Romanesque buildings across the city in the coming years.

THE 1865 SMITHSONIAN FIRE

Unlike most public buildings in Washington, the Smithsonian Castle was spared occupation by Union forces during the Civil War. For example, the Patent Office served as a hospital, and the Corcoran Art Gallery was taken over by the War Department. However, the castle wasn't spared disaster.

On the afternoon of January 24, 1865, a stove caught fire in the castle and quickly spread to the roof and upper floor. "The fire, as it mounted the central tower, and burst forth in full volume from the main roof, was magnificently grand," the *Evening Star* reported that same day. The police and fire departments were quickly summoned. A large crowd gathered as the upper part of the building was engulfed in flames and smoke. Smithsonian employees raced to remove parts of the collection before the flames could consume them. The Regent's Room and the lecture hall, which could seat up to two thousand people, were gutted. "A portion of the east tower on the north front fell about 4:15, with a terrific crash, causing a general scattering of the crowd, but fortunately no one was injured," the *Evening Star* wrote.

Fireproofing had prevented the fire from consuming the entire building. The first floor, the west wing and the east wing (home to Secretary Joseph Henry and his family) were spared. A special committee of the board of regents, consisting of just two people, including Henry, tried to sugarcoat the situation: "The burning of the roof of the building can scarcely in itself be considered a calamity, since it probably would have occurred at some future time when a much larger accumulation of valuable articles might have been destroyed, and since the arrangement of the building can now be improved, and the repairs made with fire-proof materials."

It wasn't a calamity unless you consider the loss of irreplaceable scientific objects, priceless works of art, most of Secretary Joseph Henry's papers and all of James Smithson's papers. Despite the special committee's words, the fire was, in fact, a disaster. Smithson would remain a virtual blank slate until biographer Heather Ewing pieced together the details of his extraordinary life in 2007.

The castle wasn't insured for loss, so the regents dug into the endowment. They hired German-born architect Adolf Cluss to rebuild the torched space. He worked on similar projects after devastating fires, including the Calvary Baptist Church in 1866 and the Patent Office in 1883. Cluss built his masterpiece, the Arts and Industries Building, adjacent to the castle in 1881. Cluss's best-known building, Eastern Market, suffered a catastrophic fire in 2007, but the subsequent renovation was nothing short of miraculous.

The Smithsonian Castle

Cluss testified before Congress in 1874 about his use of Seneca sandstone and told an interesting story about the rebuilding efforts in the aftermath of the castle fire.

Q: Have you used the Seneca stone yourself?

A: Extensively. I used it first in the reconstruction of the Smithsonian after the fire, and there was one remarkable fact connected with that experience. It was during the [Civil] war, and the place where the quarries were located was so far on the disputed ground that all work stopped, and it was difficult to get stones from the quarry. After a good deal of trouble I heard that a considerable quantity of stone from the original building had been left over. I looked for it and found that the Government had built temporary sheds over it. They were up in the first ward. After some negotiation we succeeded in having these sheds removed, and we bought these stones at a low rate. After we had bought them, I found that by exposure for fifteen years they had become so hard as to make it difficult to work them.

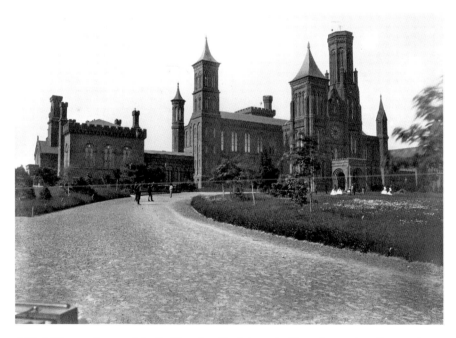

A Civil War–era image of the Smithsonian Castle's north side and east wing. *Courtesy of Library of Congress.*

Cluss had witnessed firsthand that Seneca sandstone hardened into an impenetrable surface. The granite workers and sandstone cutters argued over who should cut it, until Cluss came up with a solution: "We preferred to go up and open the quarries, which we worked at our own expense, and got the stone."

The castle was rebuilt with significant modifications, and new museums were added as the Smithsonian Institution expanded. But that wasn't the end to architectural changes to the castle. In 1903, telephone inventor Alexander Graham Bell and his wife retrieved James Smithson's remains in Genoa, Italy, where Smithson was buried, and brought them to Washington. The architectural firm Hornblower & Marshall designed a crypt for Smithson two years later adjacent to the north entrance.

Today, the Smithsonian continues its mission "for the increase and diffusion of knowledge" with sponsored research and more than twenty museums. The castle is the most recognized building at the National Mall, and it is often the first place that visitors to Washington come. It is a symbol of the larger institution while standing literally at the Smithsonian's core.

The Civil War Comes to Seneca

Maryland was a slave state, and many expected the state to join the Confederacy at the onset of the Civil War. However, given that the nation's capital, Washington, D.C., was deep inside Maryland, President Abraham Lincoln could not allow the state to fall to the Confederacy. He revoked the writ of habeas corpus to prevent the Maryland legislature from meeting and voting to secede. Union forces streamed in to protect the capital in a ring of fortifications. Other units spread out to protect the Potomac River against Confederate raids, while Union gunboats patrolled the lower river to halt Confederate shipping. Maryland was essentially occupied.

The Maryland Piedmont, of which Montgomery County is part, was divided in its sentiment. It had plantations, such as the Peters's, but they tended to be small—most had nine or fewer slaves. The rolling hills and thin soil of the Piedmont weren't ideal for growing tobacco like the Tidewater flatlands. Piedmont farms grew more foodstuffs, like corn, fruit, hogs, wheat—and, today, horses. You don't see tobacco barns in the Piedmont like in Charles or St. Mary's Counties.

Montgomery County towns like Poolesville organized militia and sent men to fight for the Confederacy. Poolesville's economy was tied closely to Virginia, as it lay near trade routes over the Potomac River to the Old Dominion: Edwards Ferry to the south, Conrad's Ferry (now White's Ferry) to the west and White's Ford to the northwest. One of the most feared Confederate guerrilla fighters, Elijah Viers White, was born in Poolesville's

Stoney Castle (a large Seneca redstone house) in 1832. After the war, he ran White's Ferry, which is still named for him.

The Potomac River formed the border between the Union and the Confederacy, and the C&O Canal found itself on the front line of a war zone. Canal workers were mixed—some favored the Confederacy, others the Union—but none wanted to risk their livelihood. It was the Confederates who targeted the canal, repeatedly attempting to knock it out. Union forces established camps along the Potomac to defend the C&O. Nearby towns like Darnestown and Poolesville would be garrisoned for most of the war.

Another vital strategic Union asset was the B&O Railroad, which passed through this region to link the east to the west. The Union expended much effort in defending it. Confederate saboteurs knocked out the B&O early in the war, and it didn't become operational again until March 1862. In the meantime, the C&O Canal became the primary supply route to Washington, especially for coal, which was vital to heat homes and power steamships.

THE OCCUPATION BEGINS

Union colonel Charles Stone put together the plan for Washington's defenses in the early days of the Civil War. In June 1861, Stone commanded the Rockville Expedition, composed of 2,500 three-month volunteers, to protect the C&O Canal and halt the flow of supplies to the Rebels while establishing a presence opposite Leesburg, Virginia. The expedition marched out from Washington, skirmishing with Confederates near Seneca on June 14 before reaching Edwards and Conrad's (White's) Ferries the next day. When Confederates attempted to challenge him by crossing Edwards Ferry on June 17, Stone brought up artillery and stopped them.

As the Rockville Expedition secured the area, the C&O Canal reopened, and Stone used it to supply his force. Canalboats carried supplies to Seneca and were then offloaded and transported by wagon to Poolesville. The Confederates stationed around Leesburg made the continuing journey along the C&O too dangerous for the time being. By August, however, the canal was reopened and carrying boats heavily laden with coal to Washington. There were frequent skirmishes from across the river.

The Rockville Expedition volunteers were replaced with Federal troops as the Union strengthened its presence to protect the canal. On August 11, 1861, now Brigadier General Stone was given command of the Corps of Observation, a

division-sized force whose task was to guard twenty-two miles of the Potomac between Seneca and Point of Rocks. Union general Nathaniel Banks guarded the river crossings to the east and set up headquarters in Darnestown. A signal station was established on the Magruder farm, a high point east of Seneca on Seneca Road, which could relay messages to Poolesville, Sugarloaf Mountain and Washington. Units that protected the Seneca area included the Thirty-fourth and Forty-second New York Infantry, the Second and Thirty-ninth Massachusetts Infantry, the Tenth Vermont Infantry, the First Rhode Island Artillery and the Sixth Michigan Cavalry.

The Potomac is shallow with many fords, making the Union encampments vulnerable to Confederate raiders. Rowser's Ford is just one mile downstream from Seneca Creek near Violet's Lock. In the fall of 1861, part of Banks Division, the five thousand soldiers under Union brigadier general Alpheus Williams, made their camp near Muddy Branch (now part of Blockhouse Point Conservation Park). They kept a constant watch along the three miles of Potomac shoreline between Muddy Branch and Seneca Creek to protect Rowser's Ford and the C&O Canal.

Robert Gould Shaw, who later commanded the African American Fifty-fourth Massachusetts Regiment and died in the attack on Battery Wagner near Charleston, South Carolina (and the hero of the movie *Glory*), served as a junior officer with the Second Massachusetts as it patrolled the Maryland shoreline. The regiment arrived in the Darnestown area in late August 1861 and remained for three months, celebrating Thanksgiving at Seneca before going into winter quarters near Frederick.

Shaw wrote his mother on November 11 from his regiment's camp near Muddy Branch: "We are in the worst camp we have ever had. It is in a hollow, where the dampness collects, and, as we have had a great deal of rain lately, it has been a perfect bog. There are more ailings among the men than we ever had before."

Shaw's regiment was soon moved to a "camp near Seneca Md.," and there he sent a number of letters. He made no mention of the quarry. He had earlier written his father on October 13 while encamped at Darnestown and explained how they kept themselves warm: "Most of our officers have had the earth dug out inside their tents four or five feet deep, and built fireplaces inside, with chimneys running through the ground to the back. A small wood-fire warms the tent completely, and makes as cheerful a little sitting-room as one can desire." The chimneys were made from fieldstone, and the soldiers would have found plenty of rocks to suit their purpose in the Seneca area.

Lieutenant Robert Gould Shaw and the Second Massachusetts patrolled the Potomac shoreline near Seneca from August to November 1861. *Courtesy of Library of Congress.*

The Civil War Comes to Seneca

Though the Confederates often attacked the C&O Canal (and knocked it out repeatedly but only briefly), the Seneca quarry was never a target. There was little demand for building materials, so the quarry shut down during the war. This cost the Peter family dearly, as they lost their quarry income and the Montevideo farm was in the war zone. With so many Union soldiers around, it would have been easy for slaves to escape.

On October 21, 1861, General Stone sent a small force over the Potomac near Leesburg—a raid that escalated into the Battle of Ball's Bluff, the largest battle that took place near Seneca during the war. Colonel (and U.S. Senator from Oregon) Edward Baker (a close friend of President Abraham Lincoln) commanded the 1,700-man force that met a similar-sized Confederate brigade under Colonel Nathan "Shanks" Evans. Baker was killed in the battle, and the Union troops fled down the bluff to their rear while the Confederates slaughtered them from above. More than half of Baker's command was casualties, and 553 men were taken prisoner. The wounded were removed to Washington on C&O Canal boats. The Congressional Committee on the Conduct of the War scapegoated Stone for the disastrous battle and ordered him arrested. He spent 189 days in prison without facing charges or trial. Today, the battlefield is preserved as part of Ball's Bluff Battlefield Regional Park near Leesburg.

By November 1861, the two sides sat watchfully waiting—the Union forces north of the Potomac, the Confederates south of the river, some of them bivouacked near Rowser's Ford. Their campfires could be seen at night. The troops settled into the boredom of garrison and patrol duty. The *Baltimore Sun* reported, "The river pickets of the two contending armies have apparently forgotten or buried the vengeful feelings aroused by the affair of Ball's Bluff, and held agreeable converse with each other acress [*sic*] the river. No leaden compliments have been exchanged there fon [*sic*] some time past."

In the winter of 1862, the Nineteenth Massachusetts Infantry built three blockhouses on a high bluff with a clear view of the Potomac River below and Virginia beyond to protect against Confederates crossing Rowser's Ford. It is these blockhouses that gave the name to today's Blockhouse Point Conservation Park, two miles southeast of Seneca.

In March 1862, the Confederates abandoned their Leesburg and Potomac River defenses, forming a new defensive line south along the Rappahannock River in advance of Union general George McClellan's Peninsula Campaign. Things got quiet on the Potomac for the next six months, yet the river was never fully secured, as the Confederates returned time and again

on invasions and raids. The river simply offered too many crossing points, and the B&O and C&O were too tempting of targets.

After repulsing McClellan before Richmond, Confederate general Robert E. Lee attempted to shift the war to Northern soil in the months before the midterm congressional elections. His Army of Northern Virginia crossed the Potomac at White's Ford on September 4, 1862. In crossing into Maryland, Lee's army disrupted a lengthy stretch of the C&O Canal. All boat traffic halted at Seneca. The *Evening Star* reported on September 12: "Canal navigation is suspended beyond a point twenty miles from here—that is, at Seneca Dam. From that point up, for from thirty to forty miles, there is no water in the canal, the Confederate forces having drawn it off a week ago, by blowing up a culvert, when they first crossed into Maryland—hence supplies for the army cannot be sent up by canal further than Seneca."

The Confederates briefly occupied Poolesville before heading to Frederick, where Lee's plans for the Maryland Campaign were left behind in the Rebel camp. Union troops discovered the "Lost Order," and McClellan pounced on Lee's army in the indecisive but gruesome Battle of Antietam on September 17, the bloodiest day in American history. Lee was forced to retreat to Virginia. The C&O Canal was gradually repaired and reopened.

MOSBY'S SENECA RAID

During the Civil War, Union soldiers were stationed at Seneca to protect the C&O Canal and Rowser's Ford from Confederate attacks. Alice Nourse witnessed the war and later described the Union camp: "At the top of the long Seneca Hill [either the steep hill above the quarry and stonecutting mill or the long slope that now makes up the Bretton Woods Golf Course] was encamped another regiment. The top of the hill was fortified, and cannons were trained on the river to prevent an attack from that direction. In this Seneca encampment an attack from typhoid fever was a greater enemy."

Without archaeological excavations, we don't know exactly where the Union camp at Seneca was. At the top of the Seneca quarry near the quarry master's house is a stack of large redstone blocks, and some have posited that this was a Union cannon emplacement. It was a natural vantage point given that there were few trees in the area at the time and that Rowser's Ford was a short distance downstream. You could see far into Virginia into what

was then called Mosby's Confederacy. Without a doubt, Union forces would have patrolled the top of the quarry.

The most significant fighting around Seneca took place on June 10, 1863, as Confederate ranger major John Singleton Mosby crossed the Potomac with one hundred men to attack a company of the Sixth Michigan Cavalry camped at Seneca. Immediately after the battle, Mosby penned a report to Major General J.E.B. Stuart:

> *Had I succeeded in crossing the river at night, as I expected, I would have had no difficulty in capturing them; but unfortunately my guide mistook the road and, instead of crossing at 11 o'clock at night, I did not get over until after daylight. The enemy (between 80 and 100 strong), being apprised of my movement, were formed to receive me. A charge was ordered, the shock of which the enemy could not resist; and they were driven several miles in confusion, with the loss of 7 killed, and 20 prisoners; also 20 odd horses or more. We burned their tents, stores, camp equipage, etc.*

This short report didn't detail how the battle unfolded. After crossing the Potomac in the early morning, most likely at Rowser's Ford, Mosby ambushed a Union patrol along the C&O towpath. He then trotted up the towpath toward Seneca and encountered another patrol, which quickly fled, but not before pulling up a drawbridge over the canal. It took Mosby another thirty minutes to cross the canal, by which time the Union company at Seneca under a Captain Deane had formed, guarding a narrow bridge over Seneca Creek (whether this was River Road or another bridge, the *Official Record* doesn't say). After a brief exchange of fire, Mosby charged over the bridge. Mosby later wrote, "They had formed a line of a crescent shape not more than 50 yards from the bridge, on which they poured a converging fire, but not one of us was touched in going over."

The Union cavalry company was routed and fled to Poolesville, where Colonel Albert Jewett formed his entire brigade, expecting a Confederate attack that never came. Responsible for guarding thirteen miles of Potomac shoreline, Jewett penned a rosier report ten days after the raid. He claimed that 250 of the enemy had attacked, when in fact the two sides were nearly evenly matched.

> *The enemy dashed rapidly up the canal, driving in the patrols, and attacked Captain Deane's company, I, Sixth Michigan Cavalry, on duty at Seneca locks. Captain Deane fell back toward Poolesville, forming line three times, and only retreating when nearly surrounded. The enemy followed to within*

Confederate ranger John Mosby raided the Union camp at Seneca on June 10, 1863. *Courtesy of Library of Congress.*

3 miles of Poolesville, when he rapidly retired, destroying the camp of Captain Deane, and recrossing the river at the point where he had crossed.

Mosby lost two killed and two wounded in the Seneca skirmish. The *Evening Star* reported the next day: "The Potomac is just now fordable almost

anywhere between the Great Falls and Harper's Ferry; so it will be a difficult task to catch [Mosby] ere he jumps back into Loudon." Mosby never stuck around long enough to be caught.

Mosby's raid proved pivotal for the Gettysburg Campaign. Confederate general Robert E. Lee moved down the Shenandoah Valley in June 1863 to cross the Potomac on his second invasion of the North. The Union Army of the Potomac paralleled Lee's army to the east, protecting the cities of the eastern seaboard. The Federals crossed the Potomac at Edwards Ferry on June 26, just a few miles northwest of Seneca. Poolesville was briefly the Union army's headquarters after the crossing.

Turned loose from covering Lee's crossing over the Potomac, Confederate cavalry general J.E.B. Stuart circled around the Union army to the east, separating himself from Lee's command in the crucial days before Gettysburg. Mosby's raid across Rowser's Ford convinced Stuart to cross the Potomac there the night of June 27. His troopers captured a C&O Canal boat and turned it sideways to form an ad hoc bridge, while other men hastily constructed a bridge near Seneca Aqueduct. Stuart's troops damaged the C&O as best as they could, destroying the gates of Lock No. 23 and its guard/inlet lock to drain the canal while also burning nine canalboats, including one in Seneca Aqueduct. He knocked the C&O out of operation for three days. Stuart captured a 125-wagon supply train at Rockville the next day, slowing his advance into Pennsylvania.

During the Gettysburg Campaign, which lasted about a month, traffic on the C&O Canal came to a halt. The Confederates inflicted considerable damage on the canal during their invasion and likewise on their retreat in July 1863. As the Confederate tide retreated, Union forces reoccupied the Potomac River line to defend it against Confederate guerrillas. The Second Massachusetts Cavalry under Colonel Charles Russell Lowell patrolled the Blockhouse Point and Muddy Branch area.

The Confederates staged one final invasion of the North, and once more the armies crossed Montgomery County. General Jubal Early crossed the Potomac at Shepherdstown and then swiftly marched east to attack Washington, D.C., in July 1864. The Union defenders were pulled back from Blockhouse Point and Muddy Branch to defend the capital. In support of the invasion, Mosby crossed the Potomac into Maryland on July 11, probably at White's Ford. The next day, he approached the Eighth Illinois Cavalry's camp at Muddy Branch and discovered that it had been abandoned. Mosby's men burned the blockhouses and camp. The blockhouses were never rebuilt.

The superintendent's lodge at Battleground National Cemetery is built of Seneca redstone. *Courtesy of Library of Congress.*

As Mosby was burning the blockhouses, Early was repulsed at Fort Stevens in Washington on July 11–12. The next day, Early began his retreat across Montgomery County toward White's Ford and Virginia. The Confederate cavalry retreated along River Road past Seneca, while the main body passed through Darnestown. The Union VI Corps under General Horatio Wright marched through in pursuit on July 14, while the Union XIX Corps followed the day after.

After the Battle of Fort Stevens, Union quartermaster general Montgomery Meigs requisitioned one acre of farmland on the battlefield to bury forty Union soldiers who had been killed. This became the Battleground National Cemetery, one of the smallest national cemeteries in the country. A superintendent's lodge was added in 1871, built of Seneca redstone, probably from the Government Quarry.

Early recrossed the Potomac at White's Ford with several thousand head of cattle and horses. The *Baltimore Sun* reported on July 15, "The rebel rear guard took the Poolesville road, and this morning early cannonading was

heard about Seneca, the supposition being that our artillery was annoying them while crossing."

The Union forces followed closely behind. Union colonel Elisha Hunt Rhodes of the Second Rhode Island Infantry recorded the civilian response to his unit passing through Poolesville on July 15: "We reached this place today and find that the Rebels are all across the Potomac River and on their own soil in Virginia. I have just returned from a ride through the village and have enjoyed the kindly greetings of the people very much. It is not like Virginia at all. The people are all glad to see us. The country is charming and is in marked contrast with that of Virginia." This may seem surprising, given that Poolesville's sympathies were with the South, but perhaps its citizens were tiring of the war.

The constant Confederate raids, which cut off farm produce shipments to the Washington market, affected the locals as much as the armies tramping over their fields. This may have turned the local population toward the Union, which may help explain the friendly reception that Rhodes observed in Poolesville. That same year, Unionists in Maryland changed the state constitution to outlaw slavery. It went into effect on November 1, 1864.

After the Union forces crossed the Potomac in pursuit of Early, the Civil War retreated from Seneca. The Eighth Illinois Cavalry reoccupied the Union camp at Muddy Branch, assigned to patrol the entire length of the Potomac from the Monocacy River to Washington. They kept a lookout for Mosby, but no more actions or major skirmishes were fought in Montgomery County.

Like the Maryland Campaign in 1862 and Gettysburg Campaign in 1863, Early's raid inflicted considerable damage on the C&O Canal. Despite the repeated Confederate attacks, the canal continued to operate—a testament to the resilience of the company and its employees—and had its busiest traffic in the decade after the Civil War.

The Seneca branch of the Peter family, who owned the Seneca quarry, fell on hard times during the Civil War. Though a slaveholding family with several farms, most of the family stayed loyal to the Union. Their family wealth diminished as the slaves were emancipated and no one was left to work the fields. Finally, the Peters decided to sell some of their property to remain financially solvent. Advertisements were printed in the *Evening Star* in April and May 1864:

For Sale—On reasonable terms, one of the most productive FARMS in Montgomery county, Md.; 22 miles from Georgetown, D.C., 1¼ from

Seneca Mill; lying on Chesapeake and Ohio Canal. It has fine quarries, one of flagging stone, good buildings, and fine fruits. For terms inquire of ROBERT PETER, *on the premises.*

This was property that Major George Peter of Montanverde, who had died in 1861, had willed to his son Robert (John P.C. Peter was his cousin). The farm lay just to the west of Thomas Peter's Montevideo property, in dangerous territory with the threat of Confederate raids.

The Civil War had closed the Seneca quarries, but as the war receded, some saw opportunity. A group of investors emerged with big plans to take advantage of the postwar building boom.

Stonecutters

The Civil War forever changed Montgomery County. Not only had the war caused tremendous economic and property damage to the area, but it had ended a way of life for both plantation owners and slaves. Maryland amended its state constitution effective November 1, 1864, to outlaw slavery. The former slaves were now free to pursue their own livelihood and their own destiny.

In the 1860 U.S. Census, Montgomery County listed 5,421 slaves and 1,552 free blacks out of a total population of 18,322. This meant that the county was 38 percent African American on the eve of the Civil War. Two years after the war ended, the county performed its own census of former slaves, counting about 3,000 who were listed by their former owners. For example, Alexander Peter had owned 8 slaves, and George H. Peter had owned 3 slaves. Robert Peter had owned 25 slaves, making him one of the largest slave owners in Montgomery County.

It's worth noting that the number of former slaves dropped significantly between the 1860 and 1867 censuses. What accounts for such a population loss? Did many slaves escape to freedom during the war, say over the Pennsylvania border or by following the Union army as it campaigned through the area? We know from the 1867 census that many of the young men served in the Union army. Did many newly freed African Americans abandon farming by seeking jobs in nearby cities?

Their freedom in hand, many former slaves in Montgomery County bought land to settle on. This cuts against the common assumption that freed

blacks always ended up as sharecroppers. African American communities developed near the C&O Canal: Scotland near Seven Locks, Tobytown on Pennyfield Lock Road and Seneca on Violette's Lock Road. The latter community later became known as Berryville when its church moved to Berryville Road in 1940. Another community, Sugarland, developed a few miles west of Seneca.

Methodist churches tended to form the center of the black communities near Seneca. The local school system was segregated, and black children could not attend schools with white children. The black community had to make do and often had little money. Many children only got a grade-school education and then by their teenage years were put to work to support their families. On the other hand, the former slaves were able to achieve a measure of economic independence by purchasing farmland. Over the generations, the fortunes of the descendants really did improve, and today most descendants are solidly middle class.

Freed slaves may have had little education, but they had skills that could be put to use in farming and working on the C&O Canal, which served as a watery highway through their communities. One of the largest private employers in the area that always needed manpower was the Seneca quarry. We know that a large number of quarry workers were white men, many of them Irish immigrants. But the quarry also employed African Americans, especially starting in the 1870s and particularly in the laborious work of stonecutting. We see this in rare photos, which are themselves some of the best documentation of the Seneca quarry that we have. These photos also demonstrate the segregation that existed even within the quarry workforce.

The Seneca Sandstone Company advertised for laborers, quarrymen and stonecutters through the early 1870s—and even once for a "boss quarryman." It seemed to be in constant need of new employees, either from high demand for its services or because workers quit from quarry mismanagement. The advertising abruptly changed in July 1873 when the quarry called for "50 experienced QUARRYMEN (colored)" in the *Evening Star*, just two months before the onset of the Panic of 1873. Had the quarry employed black men before this? It seems likely, but we simply don't know.

Quarry workers did not have easy lives—cutting stone was hard and dangerous labor. One worker in particular rises in our memory, as his family stayed behind when most others moved away after the Seneca quarry closed in 1901. He was John Clipper, or Jack, as he went by.

Clipper was born into slavery in 1840 in Hanover, Virginia. During the Civil War, the Union army freed him in Louisa County in 1864 and put

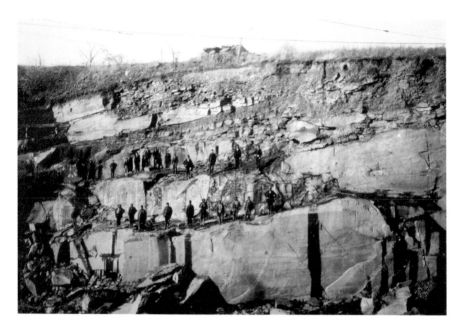

Two rows of Seneca quarry workers from the 1890s—African Americans below, white workers above. The stone outcropping at the top still stands above the quarry. *Courtesy of M-NCPPC Historic Preservation, Michael Dwyer Collection, O'Rourke family photo.*

him on a ship to Baltimore. He eventually made his way up the Potomac cutting wood. He met Martha Johnson and settled at Seneca, probably right after the war. Martha is listed in the 1867 former slave census as sixteen years old and having an unnamed one-year-old child, which must have been her first child, George. William and Louisa Vinson had owned her family before emancipation.

We find Jack and Martha Clipper again in the 1880 and 1900 U.S. Censuses (records of the 1890 Census were destroyed in a fire). They had a house full of children: George (1867), John (1869), Joseph (1871), James (1875), Barbara (1876), Bosey (1878), Nicholas (1879), Ike (1881), William (1883), Cleveland (1885), Martha (1887), Harry (1889) and Julia (1891). By 1900, the eldest son, George, had moved into his own home after marrying a woman named Lucy and was raising three children, while the eldest daughter, Barbara, had married Henry Jackson in 1892. Other children— Joseph, James and Nicholas—don't appear on the 1900 Census, so they may have died or moved away.

African Americans such as Jack Clipper and his sons were commonly listed as "day laborer" in the census records, indicating that they held many

different jobs, whether working on a farm, laboring as a blacksmith or serving on the C&O. For those like Clipper who worked at the quarry, a second, third or fourth job was necessary—the quarry was a fickle employer. It shut down for months every winter, closed for seven years after the Seneca Sandstone Company's bankruptcy in 1876 and shut down for two years after the 1889 flood. As day laborers, the black workers weren't considered employees like white quarry workers, meaning that they had fewer rights and, possibly, lower pay. White employees got more privileged positions in the stonecutting mill, polishing and shaping stones before they were shipped to customers.

In December 1884, an African American worker at the quarry, John Timms, was convicted of stealing two hundred feet of rope from the Seneca quarry. He had been hired to rig the derricks, but when the company didn't pay the two dollars that it owed him, he took it out in kind—and was caught. "He was fined $20 or 60 days in jail. Appeal noted," reported the *Evening Star*.

Many of the blacks who worked at the quarry lived around Seneca, but not all. A few, like Samuel and Wallace Lee, commuted from Sugarland, about two miles to the west. At the center of their community was St.

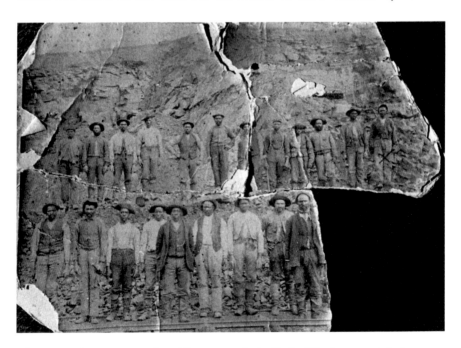

African American quarry workers. The man marked with the *X* in the upper right is Wallace Lee. *Courtesy of Montgomery County Historical Society, Rockville, Maryland.*

Paul Community Church, built in 1893 on Seneca redstone foundations. Suzanne Johnson's great-grandfather, Wallace Lee, worked at the quarry. "My grandfather's house is still there," said Suzanne Johnson, retired schoolteacher and granddaughter of Wallace's son, Tilghman Lee, though the family abandoned the house. As the quarry closed and farming declined, people looked elsewhere for work, and many people moved. "There are very few left of the original families" in the Sugarland area, Johnson noted.

Gwen Hebron Reese is the community historian and president of the Sugarland Ethno History Project, which seeks to document the local history of African Americans who transitioned from slavery to freedom. St. Paul Community Church is now a museum documenting the community life. Much of the community has scattered around the Washington area or farther, but like many rural churches it hosts an annual homecoming where family and friends gather to reconnect.

Jack Clipper died on June 19, 1903, two years after the quarry shut down; his wife died in 1905. Jack and Martha are buried in the quarry cemetery, deep in the woods near the Government Quarry, as is their son John. Their

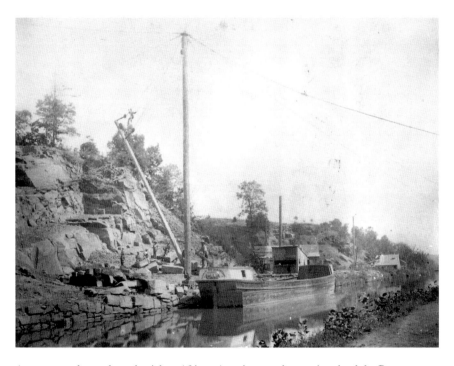

A quarry worker scales a derrick as African American workers wait to load the Potomac Red Sandstone Company boat *Gallia* in this 1880s photo. *Courtesy of Montgomery County Historical Society, Rockville, Maryland, and Gwen Reese, Sugarland Ethno History Project.*

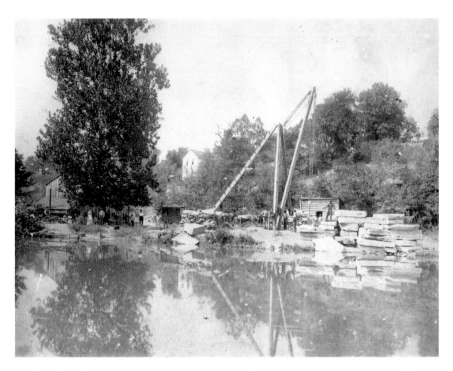

A C&O Canal loading station and settlement, possibly the Seneca quarry that John P.C. Peter purchased in 1837. *Courtesy of Montgomery County Historical Society, Rockville, Maryland, and Gwen Reese, Sugarland Ethno History Project.*

headstones are simple polished redstone with hand-cut lettering. Supposedly, one hundred people are buried at the cemetery. Only about a half dozen tombstones are visible, almost all of them propped up against trees, though other large rocks lie about that may very well be grave markers. The standing tombstones are in remarkably good shape, the stone having weathered well and the lettering still quite legible. It is a quiet and peaceful place for the dead to rest, but it is also sad that the site has largely been forgotten and is so inaccessible.

In 1925, a year after the C&O Canal closed, Jack and Martha Clipper's son, Harry, bought two acres of land on Berryville Road, about a mile inland from the river. Several brothers soon joined him, and this became the start of the Berryville community. Many descendants of former slave and stonecutter Jack Clipper still reside along Berryville Road, clustered around the Seneca Community Church.

The African Americans of Seneca and Sugarland once buried their dead in the quarry cemetery, but it was isolated and inconvenient to reach,

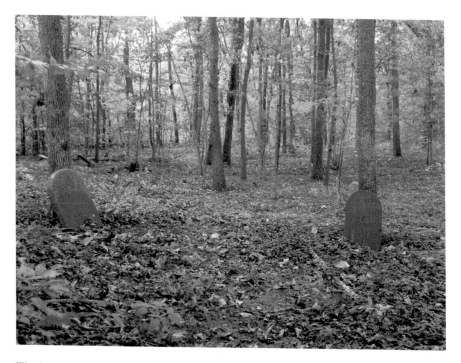

The Seneca quarry cemetery lies deep in the woods and is difficult to reach. Tombstones include those of Jack and Martha Clipper. *Courtesy of the author.*

especially as the quarries closed down. In the 1920s, the Seneca black community started a new cemetery behind its church. The Potomac Grove Colored Methodist Episcopal Church was founded on Violette's Lock Road in Seneca. Adjacent to it was the black school. The church remained there until 1941, when it was moved to Berryville Road—where many of Clipper's descendants live—and reaffiliated as Seneca Community Church.

Seneca Community Church still buries its deceased in the cemetery behind where its first church and schoolhouse once stood on Violette's Lock Road. It's a quiet, humbling place. A number of the tombstones are Veterans Administration tombstones, showing the community's service during World War II and the Vietnam War. A few tombstones are heartbreaking to see, just a simple piece of red fieldstone, the letters inscribed by hand.

Perhaps a simple redstone marker is fitting for stonecutters such as Jack Clipper. The men who worked in the quarries had hard lives but lives also marked by the gift of freedom. A simple marker reminds us of the redstone they once quarried in hopes of passing on a better life to their families.

The Seneca Stone Ring Scandal

After the Civil War, a new group of investors anticipated the postwar building boom and decided to buy the Seneca quarry from the Peter family. Their investment and influence peddling among key Republican players led to a national scandal for the administration of President Ulysses S. Grant, and the financial shenanigans of the company partners would contribute to the Panic of 1873, the collapse of the Freedman's Bank and ultimately the bankruptcy of the Seneca quarry, as it ceased operating and was put in court receivership for seven years.

PRESIDENT GRANT'S SENECA SANDSTONE COMPANY STOCK

Ulysses Grant was the general who won the Civil War and later became president of the United States from 1869 to 1877. Historians have unfairly considered him one of the worst presidents, though he has been reexamined in recent years and his reputation improved. Grant's two terms in the White House were marked by multiple controversies, one of which involved the Seneca quarry.

The scandal was rooted in a business opportunity. Dr. John L. Kidwell was a Georgetown druggist who became a major pharmacy supplier to the

The Seneca Stone Ring Scandal

Union during the Civil War. A small fortune in hand, he purchased Halcyon House, paying for it in cash, then found what he thought was a splendid idea: supplying Seneca sandstone for the building boom in postwar Washington. Kidwell teamed up with four other men: Henry D. Cooke, Henry H. Dodge, James Heath Dodge and Thomas Anderson. They purchased the moribund Seneca quarry and 614 acres from Thomas Peter (John P.C. Peter's son) in 1866 for $70,000 and began making capital improvements. They chartered and issued stock in the Maryland Freestone Mining and Manufacturing Company, better known as the Seneca Sandstone Company, on August 20, 1867. It was capitalized at $500,000.

It had been two decades since the Smithsonian Castle was built, and with the Civil War having closed the quarry, the Seneca quarry needed refurbishing. The investors poured money into improving the quarry. They constructed a new stonecutting mill four times the size of the old mill at a cost of $50,000. They hired one hundred workers and hoped to expand the workforce to three hundred. "Our city is indebted to a great extent for this addition to the elements of our prosperity to the enterprise and energy of Henry D. Cooke, Esq., of the banking house of Jay Cooke & Co.," the *Daily National Intelligencer* gushed in February 1869.

The Seneca Sandstone Company purchased and registered eight C&O Canal boats to haul stone to the capital. It opened a local office at K and Twenty-eighth Streets (now Rock Creek Parkway), close to the C&O Canal's

Two out of eight Maryland Freestone Co. boats registered with the C&O Canal in 1873. The boat second from bottom was named after Henry H. Dodge, a past and future president of the company. *Courtesy of National Archives and Records Administration.*

Tidewater Lock. It had a wharf along the creek for boats to unload their wares for delivery in the city. The company began advertising in local papers.

Henry Dodge, one of the five owners and its first president, later testified before Congress in February 1876 about the Seneca Sandstone Company's formation and its capitalization. After the partners bought the quarry from Thomas Peter, he said, "We had spent a large sum of money on the property before the company was formed, in erecting mills and derricks, boats, dwelling-houses, and other works connected with the opening of a work of that sort." He recalled that the partners spent about $120,000 on purchasing the land and making improvements, leaving about $380,000 in untouched capital. That should have been a comfortable cash cushion to finance the company's daily operations, at least in theory. The reality was that the company never had that much money on hand.

Dodge was president for only the first year. When he declined to be reelected to the board, Henry Cooke bought out his share in July 1869 for fifty cents on the dollar. "He gave me bonds at par in part, and money in part. I sold the stock out at fifty cents on the dollar and took part in money, a lot in Washington, and bonds of the company at par," Dodge recalled. What bonds? asked the examiner. "The first-mortgage bonds of the company." The company was only a year old and it had already taken out a $100,000 mortgage. Why did a company that supposedly had plenty of capital in the bank need such a large infusion of cash?

Turning to the question of who had received stock in the new company in 1867, the examiner asked, "To whom were shares of that stock issued, and in what amount?" Dodge replied: "I cannot tell the amount. I can tell you some of the first parties interested in it. They were Caleb Cushing, [Secretary of State] Wm. H. Seward, General Barnes, (Surgeon-General of the Army), General U.S. Grant, General Robert Williams, William S. Huntington, J.C. Kennedy, I think, and General Fred. Dent (brother-in-law of the President). I don't call to mind any others."

In fact, there were many more investors, and listed together they were a who's who of Republican leaders. Some subscribed for two hundred shares of the company at $100 per share, while others purchased one hundred shares. "Did any of them pay the full value of $100 a share for the stock issued to them?" the examiner asked. "No," Dodge replied. "They paid fifty cents on the dollar." Grant received $20,000 worth of shares on November 22, 1867, paid out by William Huntington. Grant had purchased (or had been given, his enemies claimed) stock in the newly formed Seneca Sandstone Company a year before his election to the presidency.

At the time, Grant was serving as both general-in-chief and as interim secretary of war while President Andrew Johnson attempted to fire Edwin Stanton. The case would lead to Johnson's impeachment the next year. Grant was already being considered as the Republican candidate for the presidency. By offering stock to a cadre of Republican leaders, the Seneca Sandstone Company was betting on the outcome of the 1868 election.

Dodge's testimony before Congress likewise showed that the company was never fully capitalized at $500,000 as its charter called for. The capital shortfall was so great that the Seneca Sandstone Company took out a $100,000 mortgage in 1868, not long after its stock sale.

In 1870, the partners raised the company's capital to $800,000 but without actually raising any funds. They simply issued stock as a dividend to the shareholders (a congressman later called this "a monstrous fabric of credit"), claiming that it showed the appreciated value of the Seneca property. They then took out a second mortgage for $75,000. And where did that second mortgage loan originate? At the Freedman's Bank, where Henry Cooke was the finance chairman and steered the money to the Seneca Sandstone Company, which he co-owned. This was a major conflict of interest. The actual lender was William Huntington, a stockholder in the Seneca Sandstone Company, a member of the finance committee of the Freedman's Bank, a cashier at First National Bank (Henry Cooke's bank) and the same man who had handed Ulysses Grant his shares. (The quarry had also named one of its eight canalboats after Huntington.)

The Seneca Sandstone Company was poorly managed. The person running the day-to-day operations was Charles Hayden, but he apparently knew little about running a quarry. "They have had no man there familiar with quarries since the latter part of 1869 or 1870, when they discharged the only man I know who knew how to manage it," Henry Dodge explained to Congress. John Kidwell followed Dodge as president of the company.

One of the final questions the select committee asked Dodge was a leading one: "General Grant and these outside parties whom you have named were simply purchasers of stock from you, as individuals?" Dodge had a single-word response: "Yes." His testimony cleared Grant and other Republicans from accusations of corruption, but the damage had been done.

One of the quarry owners, Henry Cooke, was a well-connected Republican and the younger brother of financier Jay Cooke, who had helped finance the North during the Civil War. President Grant appointed Henry as the first governor of Washington, D.C., in February 1871. Shortly after that, the scandal erupted when Grant's stock ownership was

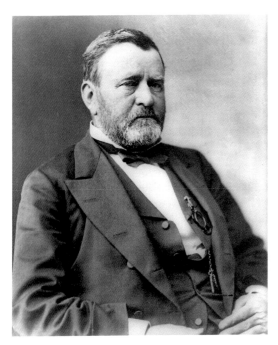

President Ulysses S. Grant was publicly embarrassed by his ownership of Seneca Sandstone Company stock. *Courtesy of Library of Congress.*

made public along with the names of many prominent Republicans who also owned Seneca stock.

Henry Cooke and John Kidwell had convinced Ulysses Grant and senior Republicans to invest in the Seneca Sandstone Company. Or was it more like an influence-peddling gift? It should be noted that it was not illegal at the time for public officials such as Grant to accept gifts, nor was it to mix business with private investment. We may never know the real answer, but the resulting controversy made national headlines. The *Baltimore Sun* called it the "Seneca stone ring," a scandal of crony capitalism and influence peddling in the early Gilded Age.

Democratic newspapers had a field day with the scandal, insinuating that the stock was really a bribe to win lucrative government contracts to supply stone for public buildings. The *Daily Albany Argus* accused the Radical Republicans of purchasing the quarry to reap profits from the government: "The stone was adopted as the building material of the government soon after the Radicals got possession of the quarry. The new sidewalks on the north front of the Treasury Department, and the north front of the Capitol, are laid in this redstone, at three times the actual cost, and the city is to be paved all over with it." This was an exaggeration, but the stock ownership seemed to prove the point. Other papers accused the administration of giving the Seneca Sandstone Company a monopoly on stone supplied to the board of public works—a false accusation at that. Few government buildings other than the State, War and Navy Building and the Department of Agriculture used Seneca sandstone when they were built after the Civil War. But this was politics, and the Democrats smelled blood.

The Seneca Stone Ring Scandal

The accusations against the stone-faced Grant were relentless. The *Harrisburg Patriot* called Grant the "Sandstone President." The *Daily Albany Argus* quipped, "The loyal rejoice that President Grant has gained twenty-eight pounds since his inauguration. 'Upon what meat doth this our Caesar feed?' Or perhaps two stone extra have come from the Seneca quarry." The *Harrisburg Patriot* penned an op-ed on October 26, 1871, that was as figuratively searing as it was sarcastic:

> *A colossal statue of Grant, to be hewn out of a solid block of Seneca stone, from the quarry in which he is a heavy stockholder, is projected by his admirers. On one side of the pedestal in which the statue is to be placed the names are to be inscribed of all who have contributed gifts to GRANT in money, houses, lands, libraries, horses, etc., with the offices to which they have been appointed. On the opposite side are to be written the names of the DENTS and all other members of the imperial family who have been pensioned on the public treasury. GRANT'S fame will thus be commemorated in the great work of art, and he will at the same time have his share in the profits of the stone that is dug from the Seneca quarry.*

President Grant was determined and unflappable, not one to bow to criticism or public pressure. Bad-mouthing in the press didn't seem to concern him. He had far greater issues to face in 1871: a landmark treaty with Great Britain that settled damage claims from British-armed Confederate commerce-raiding ships such as the *Alabama*; the attempted annexation of Santo Domingo; home rule for Washington, D.C.; the Chicago fire; and the Ku Klux Klan's continued terrorism of black citizens. He was also preparing for the 1872 election campaign.

More than six months after news of the stock ownership broke, Grant directed Seneca Sandstone Company president John Kidwell to sell his company stock in November 1871 (the letter doesn't appear in Grant's official papers). This was not a bow to his critics—Grant simply needed the money. That month, he took a personal loan of $6,000 from a friend. It isn't known how much (if anything) Grant got back from his stock investment.

The *New York Times* was one of the few newspapers that took Grant's side: "This stock was purchased by the President long before he was nominated for the Presidency, and he has yet to see the first dollar of revenue from it. If some of those who have been impugning his motives in the possession of it will now kindly step forward and purchase it, they may learn how much its possession has been worth." The *Times* believed the quarry's prospects were improving.

In fact, the quarry's troubles were just beginning.

A congressional committee met in early 1872 to determine whether any governmental impropriety had taken place because of the Seneca stock scandal—and to ask if Seneca redstone was safe to use. Witnesses were called from the State, War and Navy Building construction (now the Old Executive Office Building), who stated that they used Seneca sandstone for partition walls but not foundations and that it was difficult to get the Seneca Sandstone Company to fulfill its contract.

The quarry's enemies began circling. *Frank Leslie's Illustrated Newspaper* summarized in April 1872, "It is claimed on one side that there is a Government Ring to secure the general use of Seneca in Government work, in order to increase the stockholders' profits. On the other side, it is claimed that a Ring has been formed, of Granite Bluestone and Limestone Companies, to drive Seneca from the market; that they are jealous if its excellence, and fear competition, etc."

THE COLLAPSE OF THE FREEDMAN'S BANK

The Freedman's Savings & Trust, better known as the Freedman's Bank, was a U.S.-chartered bank formed in 1865 to help newly freed slaves establish economic independence after the Civil War. It moved to Washington, D.C., in 1867 and built a grand headquarters building at 1509 Pennsylvania Avenue, Northwest (now part of the Treasury Department annex) with Seneca sandstone. Trouble was brewing at the bank, in part because of the shady loans that Henry Cooke had issued. The bank engaged in loose accounting, made very questionable investments and loans that earned no interest and had more in liabilities than assets. It was overextended.

Besides serving on the board of the Freedman's Bank and co-owning the Seneca Sandstone Company, Henry Cooke oversaw the Washington office of Jay Cooke & Co. In September 1873, Jay Cooke declared bankruptcy, triggering the financial Panic of 1873. The panic pushed the Freedman's Bank to the brink of insolvency. After witnessing a congressional investigation of the bank's plight in April 1874, the *Baltimore Sun* reported, "There seems to be no doubt that a large portion of the assets have been loaned to persons here on worthless securities. A run on the institution is expected." The bank soon folded. More than 400,000 former slaves had deposited their life savings with the bank; few ever got their money back. The economic depression that

The Freedman's Bank issued loans to the Seneca quarry and others that could never be repaid. The bank collapsed after the Panic of 1873. *Courtesy of Library of Congress*.

followed the panic and the bank's collapse exacerbated the poverty of many former slaves.

The Panic of 1873 began an economic depression that would last through the decade. It sapped the North's desire to continue with Reconstruction after the Civil War. The panic also ended Washington's

brief experiment with home rule in 1874; the city wouldn't achieve home rule again for a century.

One of the questionable investments the Freedman's Bank had made was a $75,000 second mortgage for the Seneca Sandstone Company. The bank had also invested $20,000 in sandstone company bonds—and hadn't received a cent in interest. The quarry was deep in debt and had no ability to pay off its loans.

As the finances deteriorated at the Seneca Sandstone Company, John Kidwell was superseded as company president in March 1874 by J.W. Alvord, who had himself been the president of the Freedman's Bank. (Among the 1874 board members was George Peter Jr., the son of Major George Peter of Montanverde.) Alvord was paid ten shares of stock and ridiculously told that this would be incentive for the quarry to repay its second mortgage to the bank. Both institutions were in financial shambles, however, and both would soon fail.

Creditors took the Seneca Sandstone Company to court and demanded payment. Unable to pay the creditors, the Montgomery County Circuit Court, on November 13, 1874, ordered that company property be auctioned. The *Baltimore Sun* cheekily wrote: "But somehow the company has always had a greater facility for absorbing money from the government than for paying its debts, and now the goods and chattels of the concern, consisting of three canal boats, four mules, a set of scales, a water bucket, two stoves and map of the United States, are to be sold at public auction next week to satisfy execution"— as if somehow these few goods could pay off the company's massive debts.

For the record, the company assets auctioned off were more than just four mules, a scale and a map. The U.S. marshal's notice, printed in the *National Republican*, listed the items that would be auctioned: two canalboats (the *General Dent* and the *Laura*); one lot of dressed Seneca redstone, and another lot undressed; and two derricks. The auction was held at the company's Rock Creek office on December 21.

The quarry somehow remained in business in 1875, but the clock was winding down to bankruptcy. The company decided to lease the quarry to its manager, Charles Hayden, in April 1875. He wouldn't operate there long.

With the impending collapse of the Seneca Sandstone Company, rumors recirculated that Seneca redstone wasn't safe for construction. After congressional hearings confirmed that Seneca sandstone was safe in 1874, the company issued a self-serving report entitled "Seneca Stone Sustained!" that stated, "After the most extensive use, during several years, it has been found that no stone, combining the two essential requisites of cheapness and superior quality, can be found equal to the Maryland Freestone." The report included

excerpts of testimony by Smithsonian secretary Joseph Henry, architects Adolf Cluss and Alfred Mullett and a great many others, as well as excerpts from the 1846–1847 building committee that had chosen the quarry's redstone for the castle. But it was too late. The company was destined for bankruptcy.

In January 1876, the bondholders of the first Seneca mortgages, worth $100,000, asked the circuit court to auction off the Seneca Sandstone Company's assets to recoup their losses. The second mortgage, the $75,000 loaned by the Freedman's Bank, was deemed worthless. The court put the remaining company assets in receivership. "The Seneca Stone Company, which is now about to go out of existence, was one of the famous enterprises which figured so extensively in the romantic history of the old Washington ring," the *Baltimore Sun* concluded. "President Grant's stock in this company is now worth just what it cost him—0."

On February 3, 1876, the Seneca Sandstone Company's first president, Henry Dodge, came before a congressional select committee to testify, and there he told the story of how the company was poorly managed and undercapitalized but that it hadn't bribed Republican leaders. A slew of witnesses were called in coming weeks, revealing the sorry state of the quarry and the Freedman's Bank.

Congress published its investigative report of the Freedman's Bank in May 1876. It noted how the bank had issued loans on the loosest of terms, often with major conflicts of interest:

> *Among the most notable examples of the reckless and improvident management that now crept into the bank are the loans to Howard University, the Young Men's Christian Association, the Seneca Sand Stone Company, in all of which there was a personal identity to a controlling extent between the parties obtaining and those who granted the accommodation.*

After reviewing the report, the *Baltimore Sun* crooned: "If the bank was not originally conceived in fraud it certainly degenerated into a monstrous swindle, and its career justified the suspicion that it was almost from the start merely a scheme of selfishness under the guise of philanthropy, and an incorporate body of false pretenses." Congress recognized that it was partly at fault for allowing the bank to invest half of its deposits in real estate loans. Henry Cooke, chairman of the bank's finance committee, was at the center of these loans, and he pushed money into the willing hands of the Seneca Sandstone Company. The Freedman's Bank ultimately lost $62,000 on its investment in the quarry. The congressional report recommended indictments for Henry Cooke and others.

Time passed. Few of the former slaves ever saw their money returned after the Freedman's Bank collapse. Many of them wrote to Senator Blanche K. Bruce, a Republican from Mississippi, then the only African American senator in Congress. Bruce organized a Senate select committee to investigate. It met in January 1880. John Kidwell, former president of the Seneca Sandstone Company, and Henry Cooke were among those called to testify. Later that year, Congress authorized the Treasury Department to purchase the former Freedman's Bank building, but this did nothing to help the depositors get their money back.

No one was ever indicted for the Seneca stone ring or the collapse of the Freedman's Bank, though it may have been beyond reasonable doubt to prosecute the lenders and leaders of the Seneca Sandstone Company. Henry Cooke is the one exception. There was enough evidence to prosecute him for his fiduciary conflict of interest and mismanagement; however, he was too politically well connected, despite Congress's call for his indictment. In any case, Cooke died in February 1881.

John Kidwell, the former company president, soon became famous for another controversy. This involved the Potomac flatlands that were to be dredged and redeveloped into what is now East and West Potomac Park. They were known as the "Kidwell bottoms," as Kidwell had bought the land in 1867 for a pittance from the federal government and then wanted to sell it back for a staggering price. He died in 1885 with the case unresolved. The case was finally closed in 1903 with the federal government as the victor.

In 1879, Ulysses Grant's name was floated for a third presidential term. No fan of Grant's, the *Washington Post* ran a sardonic column entitled "Symptoms of Grantism." It began: "General Grant may be the next president, and then the good old days will come again—the good old days of Credit Mobilier, Pomeroy, Patterson, Colfax and Oaks Ames; the fine old days of Belknap, Orvil Grant and Indian posts bought and sold; of whiskey rings and Joyce, Avery, McKee and Babcock; *of Seneca sandstone quarries* [author's italics] and St. Domingo commissions," and so on in a lengthy list of controversies. It concluded, "Dost like the picture?"

Was President Grant guilty of corruption in the Seneca stone ring? Certainly not. His administration suffered a number of controversies, but he wasn't the root of the scandals. Grant was unquestionably an honest and incorruptible person, but he was prone to trust political cronies such as Henry Cooke, who often had conflicting interests. Grant was a gullible investor in the Seneca Sandstone Company, albeit one given a supposedly sweetheart deal. Not so sweet, it turns out, given the public relations embarrassment that followed.

Chapter 7
The Building Boom

Today we think of Washington, D.C., and its monumental core as pristine buildings enshrouded in limestone and white marble. But this was something that largely dated to the twentieth century. In the second half of the nineteenth century, Washington's predominant building color was red—red from the many pressed brick buildings that architects like Adolf Cluss designed and rusty red from the buildings constructed of Seneca sandstone. Knight Kiplinger, a journalist and avid student of Washington history, called Seneca redstone "the stone that built Victorian Washington." This chapter is a survey of the many confirmed buildings that incorporated Seneca redstone.

Romanesque Revival was one of the leading architectural styles that dominated Washington for five decades, from the building of the Smithsonian Castle until 1900, along with French Second Empire, Gothic Revival and Italianate. If a man's home is his castle, then Romanesque strove to give man that castle. It often goes by the name Richardsonian Romanesque, a Victorian style named after prominent architect Henry Hobson Richardson (1838–1886). Architectural historian and former Smithsonian Castle curator James Goode described this style: "It's often asymmetrical, and often stone, but it can be brick as well. And often it can have towers. It offers massive bold treatments to the windows and doors." The dominant color was brown. Architecture historian Lewis Mumford called this era the "Brown Decades."

Besides round arches and bow windows, Romanesque often incorporated sandstone at the basement level or even up to the first floor, with pressed

red brick above that. Sandstone is dense and resists erosion, and thus it was often used for basements to keep out groundwater. "And it blended in with the brick façade," Goode added, which often included ornate sandstone carvings. Sandstone is soft to carve, though it hardens over time.

It wasn't just Washington that used Seneca sandstone; Baltimore often built Victorian-era buildings with Seneca redstone. You see this especially around the Mount Vernon Historic District. This includes such places as the Baltimore Club (1887, 914–916 North Charles Street); the exquisitely carved Romanesque arches over the Booker T. Washington Middle School (opened in 1895 as the Western High School at 1301 McCulloh); and the Richardsonian loading dock at Crown Cork and Seal's former headquarters (1904) at 1501 Guilford Avenue, the last building constructed from Seneca sandstone quarried directly from Seneca. Baltimore was on the B&O Railroad, so sandstone could be transported up the C&O Canal until it reached the railroad at Point of Rocks and then transferred to a railcar.

Another popular building material was Hummelstown brownstone, a chocolate brown sandstone from a quarry near Harrisburg, Pennsylvania. When local builders couldn't get Seneca sandstone, they substituted Hummelstown, which was shipped by train. It was commonly used across the mid-Atlantic (New York's famed brownstones largely come from a quarry in Portland, Connecticut). The best examples of this in Washington are the National Union Insurance Company Building (918 F Street NW) from 1890; the T. Franklin Schneider–designed town houses on the north side of Q Street NW between Seventeenth and Eighteenth (1889); the 1891 St. Joseph's Catholic Church (Second and C Streets NE); and Metropolitan Wesley AME Zion Church (North Capitol and R Streets), which opened in 1905 as the Memorial Church of the United Brethren in Christ.

How to tell the difference between Seneca and Hummelstown sandstone? It isn't always easy. Seneca offers varying shades of red, from dusty pink to rusty brown, while Hummelstown looks like greying milk chocolate. They are easily confused. If you ever see the German-American Building Association headquarters from 1909 (179 Third Street SE on Capitol Hill), you'd swear it's Seneca redstone, but it isn't. The first floor is Hummelstown sandstone.

How prominent is Seneca sandstone compared to Hummelstown in Washington? Judging by the permit records, Hummelstown wins hands down. Seneca produces six pages of permit listings, while Hummelstown produces forty-three pages. However, the permit database begins in 1883, after the Seneca quarry had already produced stone for many public buildings.

The Seneca quarry certainly had no monopoly on the Washington brownstone market. Other redstone was shipped in from Longmeadow, Massachusetts, and Potsdam, New York. Perhaps the best Richardsonian Romanesque house in Washington is the Denman-Werlich House at 1623 Sixteenth Street NW, built in 1886. The sandstone looks like Seneca redstone, but it isn't. Rather, the sandstone came from the Longmeadow quarry.

Before the Seneca quarry's 1882 auction, a *Washington Post* advertisement concluded, "The supply of the justly celebrated Building Stone in the Quarries is believed to be almost inexhaustible." Not quite. The quarry would have another two decades of active quarrying ahead of it, and it would make a noticeable impact on the city's housing market during the building boom.

CHURCHES

We begin our survey with churches, which were the most immediate outgrowth from the Smithsonian Castle design competition. Wealthy banker and art collector William Wilson Corcoran (1798–1888) donated land at Third and C Streets NW (now Judiciary Square) to build a church. He was suitably impressed by the young James Renwick's design for the castle, and Renwick had a ready-made idea for a Gothic Revival church—it was his first submission for the castle that was rejected. Corcoran persuaded Renwick to adapt the design for Trinity Episcopal Church, including its two signature crown-like towers. The new church was built in 1849 of Seneca redstone at the same time as the castle was being erected. As residents decamped to other neighborhoods in the late nineteenth century, the church declined. It was demolished in 1936. A photo taken around 1860 of the church and the U.S. Capitol graces the cover of James Goode's definitive book *Capital Losses*.

A block to the west stood another prominent Washington landmark, Memorial Methodist Church, at C Street and John Marshall Place NW. The Gothic Revival church was begun in 1854. Construction halted during the Civil War but resumed in 1869 and was completed thee years later. Matthew Emery (Washington mayor 1870–1871) was the contractor who brought Seneca sandstone to the city and built the church's foundations. President Ulysses Grant served as a trustee. The church had a distinctive 240-foot needle-like spire that was a Washington landmark. James Goode wrote in

James Renwick designed the 1849 Trinity Episcopal Church based on one of his submissions for the Smithsonian Castle competition. *Courtesy of Library of Congress.*

Capital Losses, "It was probably the most important of more than seventy-five Gothic Revival churches that have been built in the Washington area in the past 175 years." Like nearby Trinity, it fell victim to a declining neighborhood, and the congregation moved to the new Metropolitan Memorial Methodist, built in 1932 near American University. The old church was razed in 1956.

Georgetown's Oak Hill Cemetery (3001 R Street NW) offers a real treat in having not one, not two but three structures made from Seneca redstone (or four if you count both sets of gates). In 1848, William Wilson Corcoran purchased the land for the cemetery. He had persuaded James Renwick to design Trinity Episcopal Church, and now Corcoran hired him again for the cemetery chapel. Renwick designed a Gothic Revival chapel that is marvelous in its simplicity: charcoal Potomac gneiss framed by Seneca red sandstone. The Renwick Chapel was built in 1850.

Renwick also designed the cemetery gate using Seneca redstone, quite possibly using a design intended for the Smithsonian Castle. The gate, built around 1850, forms the cemetery's main entrance by the brick Italianate

gatehouse. The cemetery replicated the main gate with another set of redstone gateposts nearby at the corner of R and Twenty-eighth Streets in 1869.

It is very rare to find crypts, mausoleums or tombstones made from Seneca red sandstone. Monument dealers preferred marble at first, which develops "sugaring" over time, but later shifted to granite. Yet Oak Hill Cemetery has that very rare item: a Seneca redstone mausoleum. On the downhill slope facing Rock Creek is the Linthicum-Dent Mausoleum, a Gothic Revival structure that commemorates the members of these families. The cemetery has no records on when the mausoleum was built or who designed it, though the first family member was interred there in 1862. Hand-carved flowers, leaves and vines adorn the tops of the pillars. The mausoleum is in dire condition—the sandstone is peeling in many places, while several cables wrap around the structure, like the hoops of a barrel, to keep it from collapsing.

Oak Hill isn't the only cemetery featuring Seneca redstone. Alexandria National Cemetery, founded in 1862, also has a number of Seneca structures. These include the superintendent's lodge (similar to the ones at Battleground and Soldier's Home National Cemeteries; all three were designed by Montgomery Meigs); a redstone wall surrounding the original part of the cemetery; and, most unusual, stanchions for a heavy chain surrounding the Samuel Hartlee family plot. The latter are in very poor condition.

After the Civil War, Washington began expanding north into the Dupont Circle area. Luther Place Memorial Church (1226 Vermont Avenue NW) was completed in 1873 as a symbol of national reconciliation after the war. Architect Judson York designed the building in 1867. On July 18, 1870, the church's building committee "moved that we build of Seneca stone, pressed about the edges, provided that the cost shall not exceed more than 10 per cent the cost of brick." Construction soon began.

The church is an imposing Gothic Revival structure that sits on a triangular plot of land on the north side of Thomas Circle. A massive eight-sided tower crowns the church. In 1884, German Emperor Wilhelm I donated the statue of church reformer Martin Luther that stands in front of the church. This is the last surviving church in the district that is clad entirely in Seneca redstone.

A few blocks north is the John Wesley African Methodist Episcopal Zion Church (1615 Fourteenth Street NW). Opened in 1894 as St. Andrews Church, the church uses Seneca red sandstone on the basement level and

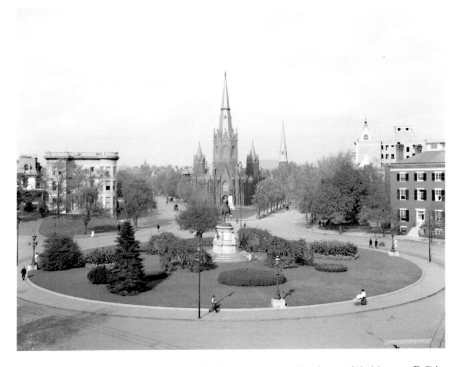

Luther Place Memorial Church, built with Seneca redstone, borders on Washington, D.C.'s Thomas Circle. *Courtesy of Library of Congress.*

brick above that. The church is perhaps best known for its large stained-glass windows.

In Chinatown stands Calvary Baptist Church (755 Eighth Street NW), an Adolf Cluss–designed red brick Gothic Revival church. In 1893, the church added a Sunday school wing whose foundation is Seneca redstone and, above that, red pressed brick. It was the largest Sunday school in Washington at the time, and it was here that the Anti-Saloon League, the organization that gave us Prohibition (1920–1933), had its first national convention in 1895.

If you drive through Washington on Interstate 395, you may notice a striking church with a green copper spire that stands parallel to the freeway at L'Enfant Plaza. This is a Catholic parish, St. Dominic (630 E Street SW), whose façade is largely granite but whose Gothic windows and doorways are framed by Seneca redstone. It was built in 1873 and miraculously survived the urban renewal that severed the Southwest neighborhood from the city in the 1950s. Once set in a thriving neighborhood, the church is framed by plain government buildings and the noisy interstate.

PUBLIC BUILDINGS

Besides the Smithsonian Castle, the Seneca quarries provided redstone for a wide array of public buildings around Washington. In the 1820s, a small amount of Seneca sandstone made it into the White House—the north and south porticoes are constructed of redstone. Two of the doorframes and adjacent flooring in the U.S. Capitol Rotunda are Seneca redstone. Originally, the building had Seneca redstone pavers leading from the western gate to the front entrance installed in the 1830s, but these are no longer extant. Likewise, the interior backing of the Washington Monument used Seneca sandstone in the initial part of the structure. The Center Building at St. Elizabeths West Campus was built in 1855 using brick and Seneca redstone. In addition, part of the perimeter wall was built in 1868, when the hospital purchased 1,500 perches (cubic feet) of rubble from the Seneca Sandstone Company.

Quartermaster General Montgomery Meigs had his hand in a number of Seneca structures, in part because he purchased the Lee quarry at Seneca in the early 1850s to supply sandstone for the U.S. Army Corps of Engineers–run Washington Aqueduct. This was because of a fire that broke out in the U.S. Capitol in 1851. The city lacked adequate water to put it out. As a result, Congress ordered the corps to supply water to the nation's capital.

Meigs took on the Washington Aqueduct project to bring water from Great Falls. The project required a great deal of stone, so Meigs acquired the Lee quarry, less than a mile west of the Bull Run quarry. After that it became known as the Government Quarry. The *Daily National Intelligencer* reported in June 1855: "The Seneca quarry, which has been purchased by the United States for the aqueduct, is supplying a large quantity of a very beautiful and durable stone for culvert walls and abutments. Some forty or fifty men are at work in this quarry."

One of Meigs's biggest challenges was how to carry Washington Aqueduct over Cabin John Creek. He solved this by building the Union Arch, better known today as Cabin John Bridge. Most of the bridge is Massachusetts granite, but the upper section—the parapet—is Seneca red sandstone, added in 1872–1873. The Government Quarry was also used for the national cemeteries in the Washington area, including the 1879 McClellan Gate at Arlington National Cemetery, and to build the Washington Aqueduct Dam at Great Falls. After completing the Great Falls Dam expansion in 1896, the quarry was no longer used. The redstone atop the Cabin John Bridge was replaced in 2001.

The Central National Bank, or Apex Building (right), has a Seneca façade. The Temperance Fountain (bottom right corner) long stood in front of the Apex Liquor Store. This photo was taken July 20, 1969—the same day that *Apollo 11* landed on the moon. *Courtesy of Library of Congress.*

I have a great fondness for the Renaissance Revival building at 631 Pennsylvania Avenue NW. It has gone by many names. It was built around 1860 as the Seaton House Hotel and then became the St. Marc in 1871. The Central National Bank bought the building in 1887 and hired Alfred Mullett for a major renovation. He added the Seneca redstone façade and the two towers that make this building so distinctive. The building was thus long known as the Central National Bank Building. However, it is often referred to as the Apex Building, as the Apex Liquor Store occupied the first floor from the 1940s until 1983. Ironically, the Cogswell Temperance Fountain stood in front of the store. Today, the building is painted pink, but underneath is Seneca redstone.

What this means is that there were once three buildings built of Seneca redstone all within a couple blocks: the Apex Building, Metropolitan Memorial Church and Trinity Episcopal Church. Sadly, the latter two were demolished in the twentieth century and the Apex Building has been painted over.

Moving a few blocks north into Chinatown, we come to the Atlantic Building (930 F Street NW), which was begun in 1887 and completed the

following year. An eight-story high-rise, the second and third floors have magnificent Romanesque carvings and windows made of Seneca redstone. Especially interesting is the buff and red checkerboard layer that separates the floors. The higher floors continue the Romanesque theme, only in brick. The building borders Ford's Theatre. Constructed as an office building with space for 150 patent attorneys, President Benjamin Harrison's inauguration committee was headquartered in the Atlantic Building after his 1888 election. The National Forestry Service maintained an office there from 1905 until 1940. More recently, the building was home to the 9:30 Club from 1980 to 1995.

Just a few doors down is the National Union Building (918 F Street NW), built in 1890. It is a beautiful Romanesque high-rise built of Hummelstown sandstone (and now houses LivingSocial). These two neighboring buildings—918 and 930 F Street—form a nice visual contrast between the Hummelstown and Seneca quarries. The former is chocolate brown; the latter is rust-colored.

William Wilson Corcoran became James Renwick's local patron for numerous buildings around Washington, many of which have sadly been torn down. The two men traveled together to Paris in 1854. Corcoran then hired the architect to design the first gallery of art in Washington— the original Corcoran Gallery of Art building (Pennsylvania Avenue at Seventeenth Street NW, across from the White House). Construction began in 1859 and was completed two years later. Renwick's design is French Second Empire. It also had Seneca sandstone on its façade in the form of wonderful vermiculated blocks that were carved by hand. (Vermiculation is carving that looks, literally, like wormholes.)

The War Department occupied the Corcoran Gallery during the Civil War, and William Wilson Corcoran hadn't been paid a cent in rent. He deeded the gallery to a group of trustees led by Smithsonian secretary Joseph Henry in May 1869, transferring the promised rent payments with it and noting that the rent would cover the building's renovation. It served as the Corcoran Gallery of Art until 1897, when the gallery moved to its new location three blocks south at 500 Seventeenth Street NW. The original building then housed the U.S. Court of Claims until 1964. By the 1940s, the vermiculated exterior had deteriorated so much that pieces were falling onto the street, and some were removed entirely. Some called for the crumbling building to be torn down, but First Lady Jacqueline Kennedy lobbied for its restoration. As a result, the building was transferred to the Smithsonian, renamed the Renwick Gallery and restored between 1965 and 1972. The

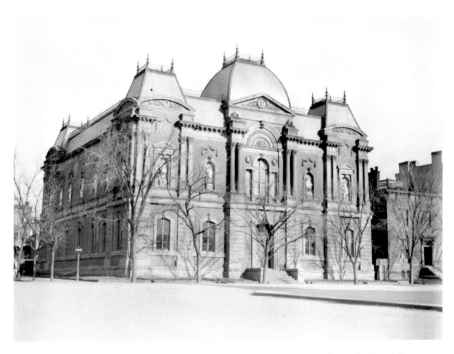

The old Corcoran Gallery of Art—now the Renwick Gallery—used vermiculated Seneca sandstone on its façade. *Courtesy of Library of Congress.*

decaying Seneca redstone was removed, crushed, remixed with synthetic Permabond and recast as vermiculated blocks. These didn't hold up well and were later replaced with yet another composite cast material.

One of the more dubious (and forgotten) buildings in Washington's history is the D.C. Jail, designed by Adolf Cluss and constructed of Seneca redstone in the early 1870s. The jail was located at Nineteenth Street and Independence Avenue SE, and the first prisoners were transferred into the jail in December 1875. It was a two-winged building, and although intended as an expansion of Washington's facilities, it quickly became overcrowded in a growing city. The city built a new jail for longer-term convicts in Lorton, Virginia, in 1916, but the D.C. Jail remained overcrowded.

Famous prisoners at the D.C. Jail include G. Gordon Liddy, one of the White House "plumbers," and Howard Hunt. Both men were convicted of conspiracy in the 1972 Watergate break-in. The city opened a new, larger prison—the current jail between Congressional Cemetery and the Armory—in 1976, but the old D.C. Jail was still used for several more years before being demolished in 1982. The Smithsonian salvaged about

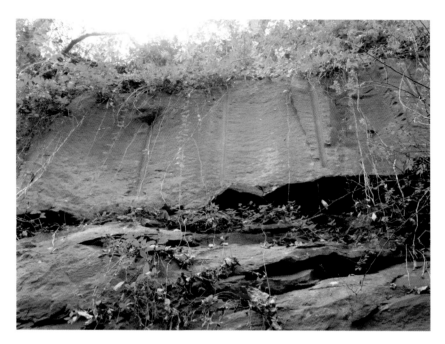

The walls of the Seneca quarry are overgrown, but it's easy to make out the distinct red sandstone. *Courtesy of the author.*

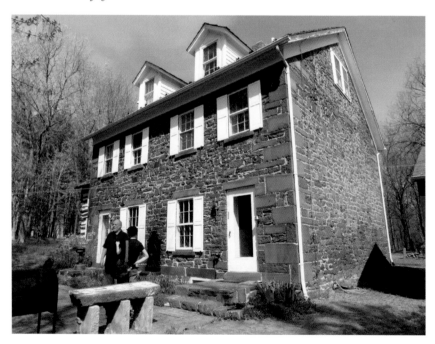

Rebecca Sheir interviews Bob Albiol, who restored and lives in the Seneca quarry master's house. *Courtesy of the author.*

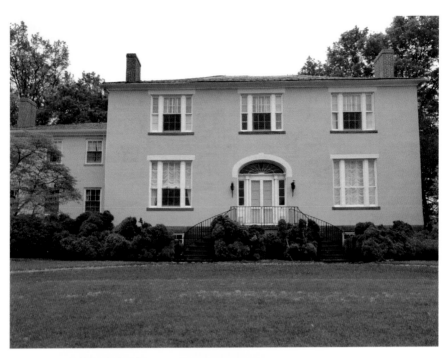

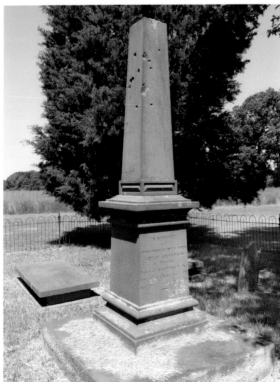

Above: Seneca quarry owner John P.C. Peter moved into Montevideo in 1830. The house was modeled on Tudor Place in Georgetown. *Courtesy of the author.*

Left: John Parke Custis Peter's grave in the Peter family cemetery at Montevideo. *Courtesy of the author.*

John P.C. Peter built an overseer's house on the Montevideo farm. Behind it were slave quarters—all constructed of Seneca redstone. *Courtesy of the author.*

The year 1835 is neatly carved in the lintel of the Montevideo slave quarters. *Courtesy of the author.*

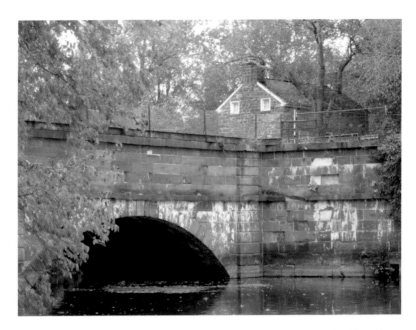

The Seneca Aqueduct on the C&O Canal opened in 1832 and is a doubly unique structure—it's the only aqueduct built of Seneca redstone and the only aqueduct that is also a lock. *Courtesy of the author.*

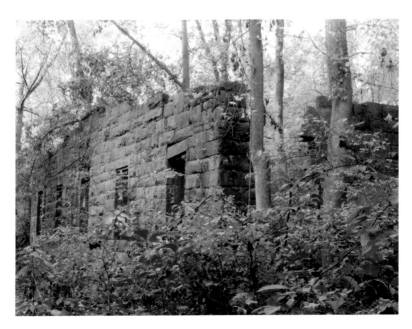

The Seneca stonecutting mill sits in the woods just north of the C&O Canal turning basin. *Courtesy of the author.*

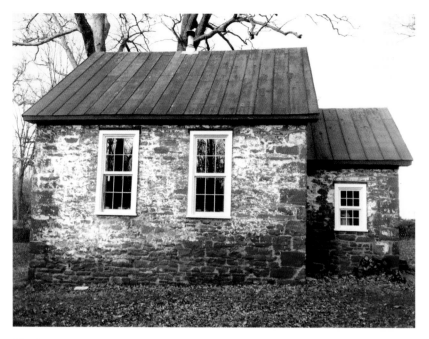

The Seneca Schoolhouse was built around 1865 to educate local children. *Courtesy of the author.*

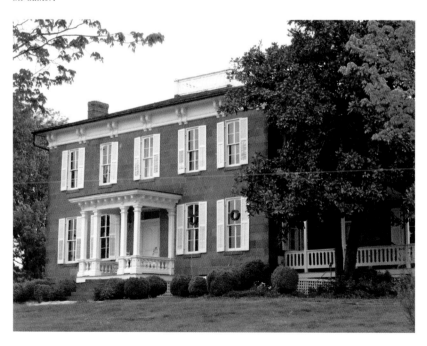

Benoni Allnutt built the Italianate villa Rocklands in 1870 of Seneca redstone. *Courtesy of the author.*

Left: Lock No. 1 of the Great Falls Skirting Canal opened in 1802 and was the first public building project for the Seneca quarry. *Courtesy of the author.*

Below: Two doorways and adjacent flooring in the U.S. Capitol Rotunda are made of Seneca redstone quarried in the 1820s. *Courtesy of the author.*

Right: One of two surviving gold sovereigns
from the Smithson bequest that endowed the
Smithsonian. On the front is Queen Victoria
of Great Britain. *Courtesy of National Museum of
American History, National Numismatic Collection.*

Below: The most well-known building on the
National Mall, the Smithsonian Castle was James
Renwick's Romanesque Revival masterpiece
that influenced five decades of architecture in
Washington, D.C. *Courtesy of the author.*

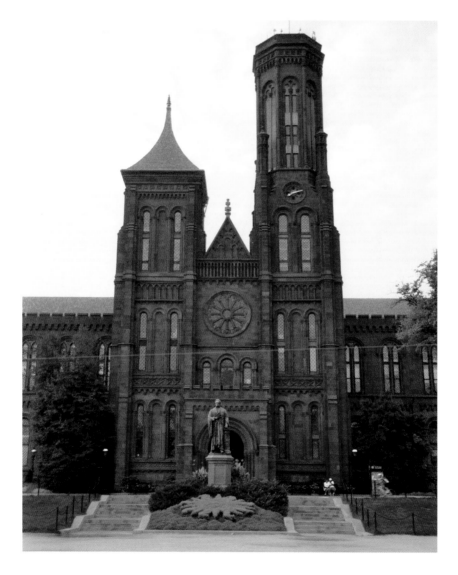

The Renwick Gate was added to the Smithsonian Castle in the 1980s using original Seneca sandstone. *Courtesy of the author.*

James Renwick designed the Renwick Chapel in Georgetown's Oak Hill Cemetery in 1850. *Courtesy of the author.*

James Renwick designed the Oak Hill Cemetery Gate around 1850. The cemetery added another similar gate in 1869. *Courtesy of the author.*

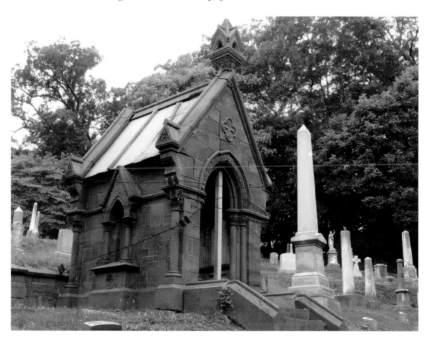

Oak Hill Cemetery houses the very rare Seneca sandstone Linthicum-Dent Mausoleum. *Courtesy of the author.*

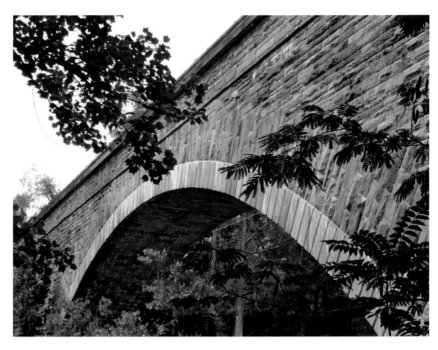

Montgomery Meigs purchased the Government Quarry at Seneca to build the Washington Aqueduct, which includes the Cabin John Bridge. *Courtesy of the author.*

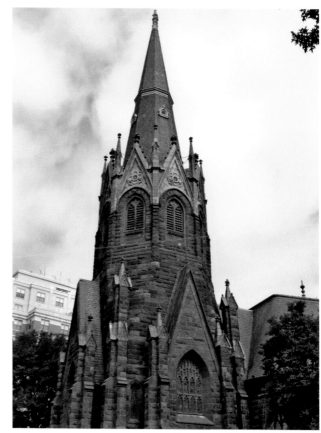

Above: A colorized postcard showing Pennsylvania Avenue and two Seneca buildings: the Central National Bank building (center) and Metropolitan Memorial Church. *Courtesy of John DeFerrari.*

Right: Luther Place Memorial Church is second only to the Smithsonian Castle as Washington's most significant surviving Seneca building. *Courtesy of the author.*

Opposite, bottom: Arlington National Cemetery's McClellan Gate, built by Montgomery Meigs. *Courtesy of the author.*

Exquisite Seneca stone carvings and Romanesque arches on the 1887 Atlantic Building. *Courtesy of the author.*

Washington's quirkiest Romanesque building is the "castle" at the Lab School. *Courtesy of the author.*

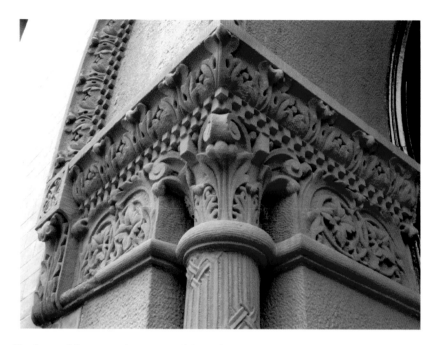

Hand-carved Seneca sandstone around the main entrance of 2001 Columbia Road NW. *Courtesy of the author.*

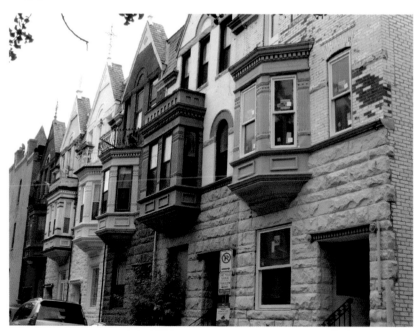

Some of the final houses built with Seneca sandstone are located on Riggs Place NW. Many owners have painted the stone to protect it from weathering. *Courtesy of the author.*

Seneca sandstone is layered and has a distinct grain, which contributes to flaking, as seen on the former Baltimore Club. *Courtesy of the author.*

The grave of Jack Clipper, a former slave who worked at the Seneca quarry. *Courtesy of the author*.

Opposite, bottom: Metropolitan Wesley AME Zion Church is one of Washington's most significant Hummelstown brownstone buildings. *Courtesy of the author*.

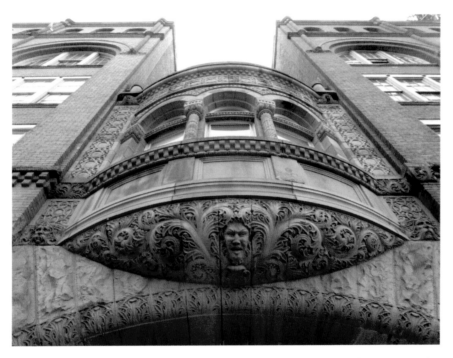

The 1904 Crown Cork and Seal headquarters in Baltimore—the last building constructed with sandstone quarried directly from Seneca. Today, it is part of the Copycat Building. *Courtesy of the author.*

The Adolf Cluss–designed D.C. Jail. *Courtesy of Library of Congress.*

Seneca redstone is removed from the walls of the old D.C. Jail in 1982 and put in storage for future Smithsonian Castle restoration. *Courtesy of Smithsonian Institution Castle Collection.*

four hundred stones from the façade (a "reverse façademy" as stone restorer Clift Seferlis called it) and stored them at its Paul E. Garber Preservation, Restoration and Storage Facility near Suitland, Maryland, for future Smithsonian Castle restoration. The cheerful buildings of St. Coletta now occupy the site of the D.C. Jail.

The last major public building to use Seneca redstone was the Library of Congress's Jefferson Building, which opened in 1897 after seven years of construction. The *Baltimore Sun* wrote approvingly, "The beautiful red platforms at the approaches are Seneca stone from Maryland, prepared in Baltimore by Mr. George Mann," the quarry's owner. The platforms evidently no longer exist or are no longer visible, probably removed in a later renovation.

HOUSES

Houses are most difficult in determining provenance. Public buildings usually are mentioned in archives or newspapers, but private homes often went undocumented, and the construction materials are only sometimes mentioned in permit records. Most houses have changed hands so many times that the current owners usually have no idea of the history of their homes, let alone what specific building materials were used.

Much of the Dupont Circle area was developed after the Civil War, which coincides with the peak years of the Seneca quarry. Many houses in the area were built with Seneca redstone. The dominant architectural style in the neighborhood is the Romanesque town house.

Homes were often built with intricate sculptures carved on-site. Many carvers were English, German, Irish or Italian immigrants. Seneca red sandstone was a preferred stone, as it was soft to carve but hardened over the course of a year. Executed in Seneca redstone in 1899 and crowned by flowers, leaves and rows of tiny boxes, the intricately carved columns surrounding the main entrance to 2001 Columbia Road NW in Adams Morgan are an exceptional example.

Located at 2025 Massachusetts Avenue NW in Dupont Circle, the Samuel M. Bryan House is a magnificent Richardsonian Romanesque mansion designed by W. Bruce Gray and built in 1885. The entire first-floor façade is lilac gray Seneca sandstone, including the turret, the double bay windows supporting a second-floor balcony and a

Romanesque arch over the recessed front door. The house served as the headquarters of the Church of the Savior from 1950 to 2008.

The Susan Shields House (1401 Sixteenth Street NW) was built in 1888 for the then-astonishing price of $40,000. It is a fine Romanesque mansion with a pressed brick façade, a big tower and a first level of red sandstone. The house is now the Embassy of Kazakhstan.

William Wilson Corcoran was clearly a fan of Seneca sandstone. Besides using it in the various public buildings that he helped finance, he also incorporated it into the façade of his 1849 James Renwick–designed residence at H Street and Connecticut Avenue. Corcoran made his fortune selling U.S. government bonds to the British to finance the Mexican War. He was a southern sympathizer, but rather than openly move to the Confederacy, he decamped to Europe during the Civil War. After the war, Corcoran built the Louise House at Massachusetts and Fifteenth, just east of Scott Circle, to provide a home for impoverished southern women from wealthy plantation families. The buildings were demolished in 1922 and 1949, respectively.

Architect and developer T. Franklin Schneider (1858–1938) built more than one thousand Romanesque row houses around Washington. He worked for Adolf Cluss from 1875 to 1883 before striking out on his own. He often used sandstone in his designs but seldom executed them with Seneca sandstone. More often he used Hummelstown or neutral sandstone. Schneider is most famous for building the Cairo high-rise.

In 1889, Schneider began an ambitious $300,000 project to develop thirty-four houses on Q Street between Seventeenth and Eighteenth. These were to combine Hummelstown, natural, Seneca and serpentine (green) sandstones. That same year, however, a massive flood knocked out the C&O Canal for two years, cutting off the Seneca quarry from Washington. Thus, Schneider largely used Hummelstown sandstone on the north side of the block and neutral sandstone on the south side to complete this notable project. The house at 1733 Q Street was the site of the sensational 1892 murder when Howard Schneider, brother of the architect, gunned down his wife, Amanda, and brother-in-law, Frank Hamlink.

One of the oddest buildings in Washington was a private residence known as Henderson's Castle on Florida Avenue at Sixteenth Street NW (now the site of the Beekman Place condominiums). It sat prominently on Meridian Hill with a fine view of the city below. Former Missouri senator John Brooks Henderson and his wife, Mary Newton Foote, began building the Romanesque castle in 1888 with Hummelstown and Seneca sandstone. Mrs. Henderson became a proponent of developing Sixteenth Street into a

fashionable address for mansions. She successfully lobbied Congress to buy the land that became Meridian Hill Park. She died in 1931, and the castle was razed in 1949. All that remains of the once prominent complex are the turret-like front gates and the retaining wall along Sixteenth and Belmont Streets that appears to be Hummelstown brownstone.

Keeping to the popular nineteenth-century castle theme, the Lab School of Washington (4759 Reservoir Road NW) has a Richardsonian Romanesque building at its core. The school informally calls it the "castle." It is a quirky and brilliantly designed building with absolutely no symmetry. It's like a medieval town where the roads keep changing names and bend around fields to avoid someone's barn. The castle was built around 1895 in the Palisades neighborhood, an area outside of the city then populated by slaughterhouses and stockyards. In the 1920s, the house became the Florence Crittenden Home for Unwed Mothers. The Lab School acquired the property in 1983 and renovated the building in 1987, removing the Portland cement mortar that had damaged the sandstone and replacing some of the more fragile rocks with similar sandstone from Germany. The castle now serves as the school's administrative office.

Riggs Place NW between New Hampshire Avenue and Nineteenth Street offers almost an entire row of houses built in 1898 with Seneca sandstone on the first level. These houses show how the quarry deteriorated in its final years, as the stone flakes and peels.

Traveling north to Adams Morgan, developer Edgar Kellogg filed permits on June 29, 1899, to build a large number of houses on Vernon and California Streets and Kalorama and Belmont Roads, almost all of which survive today. These were some of the last homes built with Seneca sandstone, given that the quarry closed the next year. Melvin Hensey was the architect for all of these houses.

At 1719 N Street NW is a Hornblower & Marshall building—mostly brick—built in 1901. It has very limited Seneca sandstone—just the doorframe and simple rectangular blocks above and below the windows. This is the last documented building in Washington built with stone quarried directly from Seneca. (Baltimore has a newer building for Crown Cork and Seal.)

One perplexing building is the two-story house at 811 Maryland Avenue NE, built in 1920. It is puzzling how this house was built with stone from a quarry that closed two decades earlier, but then again, many Victorian-era buildings around downtown Washington were already being demolished. It could be that the builder scavenged Seneca sandstone in an early example of building material recycling, but that is simply speculation. Or

it could be that the builder wrote down "Seneca" on the permit when he really meant "Hummelstown."

There remain many buildings that have redstone features, yet there are no records to prove that they are made of Seneca sandstone. Unless there is an archival record, building permit or newspaper article that specifically mentions Seneca, we can only speculate. The amazing T. Franklin Schneider–built house at 1752 N Street NW, with its intricately carved redstone below a double set of oriels, is a great example.

Three public schools—Giddings (now Results, The Gym on Capitol Hill), Grimké and Ross—were identically built in 1887 and 1888 with redstone platforms. Capitol architect Edward Clark approved their designs, as Congress appropriated the money. Given that the government could have used stone from its own quarry at Seneca, these schools very well may include Seneca redstone. But where's the documentation to prove it?

Two houses, 2100/2102 Seventeenth Street NW and 1700/1702/1704 Florida Avenue NW, were designed by E.D. Frazier and built in the "Striver's Section" (the wealthy African American neighborhood north of Dupont Circle) in 1891. They were built shortly after Henderson's Castle went up, and their color resembles the castle's surviving gate and retaining wall. They could be Seneca—or they could be Hummelstown sandstone.

What about the Phillips Collection (1612 Twenty-first Street NW), with its rusticated basement and polished redstone window frames? It was built in 1897 and designed by the renowned firm of Hornblower & Marshall, which also designed the nearby Fraser Mansion (1890). They may have used Seneca sandstone—but maybe not. The quarry was closed after the 1889 flood when the Fraser Mansion was built, and in 1907, the architects added on to the Phillips house using the same materials. This was after the Seneca quarry closed for good, meaning that the builders likely sourced the sandstone from a different quarry.

See how tricky this gets? It requires a great deal of sleuthing—and often the record comes up empty. There are no quarry company records.

Jeff Moulds and Brent Anderson purchased 1752 Seventeenth Street NW in 2002, a rare 1891 Romanesque town house that wasn't chopped up into apartments. The developer, S.B. Priest, simultaneously built the adjoining houses at 1702 and 1704 S Street—all for $18,000. Moulds pointed out how much work it takes to maintain an old house: "We have done a substantial amount of foundation work, brick repointing, window and roof lantern replacement, roof replacement, slate valley and gutter replacement." The house had a brief cameo in *All the President's Men* in the scene where Dustin Hoffman and Robert Redford turned right

onto Seventeenth Street. You can see the house in the background—it was painted bright blue at the time. But did the developer use Seneca sandstone? We simply don't know.

CATALOG OF BUILDINGS WITH SENECA RED SANDSTONE

THIS LIST INCLUDES confirmed Washington-area buildings constructed at least in part with Seneca red sandstone. Documentation can include an archival record, a building permit or a newspaper report. Many other buildings were probably built with Seneca redstone but would require documentation to make the list.

Seneca Historic District

Montanverde: foundations
Montevideo: overseer's house (River View), slave quarters and barn (demolished)
Rocklands and dependencies
Montevideo Road stone fence
Darby barn
Seneca Schoolhouse
Quarry master's house
Stonecutting mill
Seneca Aqueduct: Riley's Lock and lock keeper's house
Turning and loading basin retaining walls
Bull Run culvert

Poolesville, Maryland

St. Paul Community Church (14730 Sugarland Lane): foundation
Stoney Castle (21111 Westerly Road)
East Oaks (21524 Whites Ferry Road): bank barn, dairy and slave quarters
Mount Pleasant (20525 Fisher Avenue)
Valhalla (19010 Fisher Avenue)
Darnall Place (17615 Whites Ferry Road)
Edwards Ferry: C&O Canal Lock No. 25, foundation of lock keeper's house and warehouse-like building

White's Ferry culvert
Eminence Farm (15410 Partnership Road): horse barn foundation
Seneca Baptist Church (15811 Darnestown Road)

Great Falls

Potowmack Canal: Locks 1–5
Washington Aqueduct dam (Government Quarry)

Washington, D.C.–Area Neighborhoods

<u>Adams Morgan–Columbia Heights</u>

2001 Columbia Road NW
1843, 1845, 1847 Vernon Street NW
1824, 1826, 1828 California Street NW
1806, 1808 Kalorama Road NW
1810 Kalorama Road NW (demolished)
1817–1833 Kalorama Road NW
1812, 1814, 1816 Belmont Road NW
1301 Girard Street NW (demolished)
1642 Oak Street NW (demolished)
2302, 2304 Fourteenth Street NW (demolished)
2414–1428 Fourteenth Street NW (eight houses, all demolished)
1406, 1408, 1410 Chapin Street NW (demolished)
1605 Irving Street NW (demolished)
3103, 3105, 3107, 3109 Mount Pleasant Street NW (demolished)

<u>Alexandria, Virginia</u>

Alexandria Canal locks (demolished)
Alexandria National Cemetery (1450 Wilkes Street): wall, superintendent's
 house and stanchions around Hartlee family plot (possibly from
 Government Quarry)

<u>Anacostia</u>

St. Elizabeths West Campus: Center Building; part of perimeter wall

Arlington National Cemetery

McClellan Gate (possibly from Government Quarry)

Bloomingdale

1504, 1506, 1508, 1510, 1512 North Capitol Street NW
14, 16, 18 Seaton Place NW
1118 North Capitol Street NE (demolished)

Brightwood

Battleground National Cemetery (6625 Georgia Avenue NW): superintendent's lodge (probably from Government Quarry)

Cabin John, Maryland

Cabin John Bridge parapet (Government Quarry; replaced in 2001)

Capitol Hill

Capitol Building: Rotunda floor and doorways; pavers no longer extant
Library of Congress: platform on approaches—probably replaced
811 Maryland Avenue NE
St. Mark's Episcopal Church (118 Third Street SE)
D.C. Jail (demolished)

Downtown

Smithsonian Castle and Renwick Gate
Washington Monument: interior backing
Department of Agriculture Building (demolished)
Apex Central National Bank Building (Seventh and Pennsylvania Avenue NW)
White House: north and south porticoes
William Wilson Corcoran House (H Street and Connecticut Avenue NW, demolished)
Renwick Gallery (exterior replaced)
Old Executive Office Building: cellar partition walls

House Where Lincoln Died (516 Tenth Street NW): outside steps (replaced)
Atlantic Building (930 F Street NW)
Franklin School (Thirteenth and K Streets NW; basement-level)
Sumner School (1201 Seventeenth Street NW; exterior wall, demolished)
Calvary Baptist Church (755 Eighth Street NW; Sunday school addition)
Trinity Episcopal Church (demolished)
YMCA (demolished)
National Republican Building (Pennsylvania Avenue and Thirteenth
 Street NW, demolished)
1204 G Street NW (demolished)
1734 G Street NW (demolished)
1815 H Street NW (demolished)
1435 K Street NW (demolished)
1731 K Street NW (demolished)
616 Twelfth Street NW (demolished)
St. Martin's Church (Fifteenth Street between L and M NW, demolished)
727 Nineteenth Street NW (demolished)
916 Nineteenth Street NW (demolished)
1330 L Street NW (demolished)
2118, 2120 L Street NW (demolished)

Dupont Circle–Logan Circle–Scott Circle

Luther Place Memorial Church
John Wesley AME Zion Church
Susan Shields House (1401 Sixteenth Street NW)
1239 Tenth Street NW
1719 N Street NW
Tabard Inn (1739 N Street NW)
Louise House (Massachusetts Avenue and Fifteenth Street NW, demolished)
1772 Massachusetts Avenue NW (demolished)
Samuel M. Bryan House (2025 Massachusetts Avenue NW)
1630 Nineteenth Street NW
1709 Nineteenth Street NW
1520 R Street NW
2021 Q Street NW
1752 Corcoran Street NW
1620, 1622, 1624 Riggs Place NW
1711–1731 Riggs Place NW

1807–1829 Riggs Place NW
1804–1814 Riggs Place NW
1838 Connecticut Avenue NW
Henderson's Castle (demolished, but the retaining wall and two towers survive on Sixteenth and Belmont Streets NW—probably Hummelstown sandstone)
S.S. Cox House (1408 New Hampshire Avenue NW, demolished)
1333 Fifteenth Street NW (demolished)
1631 Nineteenth Street NW (demolished)

Georgetown–Foggy Bottom

Georgetown University (from the blue-grey Seneca "College quarry")
Oak Hill Cemetery: Renwick Chapel, two gates and the Linthicum-Dent Mausoleum
1619 Thirty-fifth Street NW
1135 New Hampshire Avenue NW (demolished)
Henry D. Cooke House (3023 Q Street NW)
St. Paul's Episcopal Church (917 Twenty-third Street NW, demolished)

NoMa/Trinidad

Gallaudet University: campus wall
Rust Hall (North Capitol at M Street, demolished)

Palisades

Lab School of Washington (4759 Reservoir Road NW)

Soldiers' Home

Soldiers' Home chapel
Soldiers' Home treasurer's office
Soldiers' Home National Cemetery (21 Harewood Road NW): superintendent's lodge—probably from Government Quarry

Southwest

St. Dominic Parish (630 E Street SW)

Chapter 8
The Quarry's Final Years

With the collapse of the Seneca Sandstone Company in 1876, the quarry was placed under court receivership and ceased operating until 1882. The Montgomery County Circuit Court decided to auction the quarry and 566 acres of adjacent farmland. Notices were run in local newspapers like the *Washington Post* and Montgomery County's *Sentinel* throughout April to alert potential buyers. The notice in the *Washington Post* read that the land "includes the celebrated Seneca Quarries of Red Sandstone, with all the Mills, Machinery, Tramways, Cars, Derricks, etc., necessary to operate said Quarries on an extensive scale."

The advertisement listed the properties to be auctioned, including the extensive farmland, the overseer's house and the farm-related buildings, as well as the quarry's "Stone Dwelling House for the Superintendent [the quarry master's house], containing 12 rooms, two large Frame Dwelling Houses, a number of Small Tenant Houses for laborers, a large Stone Mill, with the necessary machinery for twenty gangs of saws: a Second Mill with the machinery for four gangs of saws, Tool Houses and other buildings essential to the proper operation of the Quarries." The auction was held on the property on Saturday, April 22, 1882.

The winning bidder was John Cassels of Washington, who paid $28.50 per acre (just over $16,000 for the entire property) and was said to represent a group of New England investors, notably General Benjamin Butler. Cassels had served as Butler's aide-de-camp during the Civil War, and the two became business partners afterward. Cassels was a capitalist long before that word got a bad reputation.

The investors created a new company, the Potomac Red Sandstone Company, and hired Henry Dodge to lead it. He was the same man who served as first president of the earlier Seneca Sandstone Company and whose congressional testimony in 1876 had helped clear President Grant of wrongdoing in owning Seneca stock. As Dodge had left the company two years before the stock scandal erupted, he was seemingly untainted. Among the board members of the new company was Nathaniel Wilson, one of the most prominent attorneys in the city and a man who, like Cassels, sat on numerous local company boards. Wilson was at one time the president of the local bar association. His wife, Anne, was also on the deed, which they signed after making the final payment on December 1, 1883.

The new company had to make extensive repairs after buying the quarry. They signed a twenty-year lease with the C&O Canal in December 1883 to rent water that powered the stonecutting mill. "The mills have been put in perfect working condition, with all the latest and most approved appliances for sawing, rubbing, &c.," a company brochure from 1884 stated, "and the Company will then be prepared to fill any and all orders for stone in any form, rough or sawed." The pamphlet reassured potential builders that "Potomac Red Sandstone" was safe for construction. It provided an extensive list of buildings made with Seneca redstone. The pamphlet came with numerous testimonials from Smithsonian secretary Spencer Baird, Montgomery Meigs, William Wilson Corcoran and Edward Clark, the architect of the U.S. Capitol. It then republished many of the documents that its predecessor company had published ten years before in "Seneca Sandstone Sustained!" Despite the new leadership and more serious investors, the Potomac Red Sandstone Company would exist for less than eight years.

The Seneca quarry was always dependent on the C&O Canal. Both businesses were subject to the vagaries of the Potomac River. Floods or "freshets" often heavily damaged the canal, such as in 1857, 1870 and 1877. The canal company repaired the damage and reopened at considerable cost. But the flood of 1889 was unlike any other. For three days, floodwaters drowned the Potomac Valley and much of the mid-Atlantic (this was the same flood that destroyed Johnstown, Pennsylvania). When the waters receded, it was obvious that it would take years to repair the damage. The flood had ripped a 150-foot section out of the towpath opposite the Seneca quarry. The C&O filed for bankruptcy. It would remain closed for nearly two years.

Without the canal, the Potomac Red Sandstone Company found itself without a way to get its stone to market. The company president, David

An idyllic view of the C&O Canal and towpath near Washington, D.C. *Courtesy of Library of Congress.*

Shoemaker, proposed an alternative. "There is a scheme on foot now that will revolutionize things along this portion of the canal," he boasted to the *Washington Post* soon after the flood, when rumor was going around that the quarry would have to close. "The plan is to build a railroad from Seneca to Gaithersburg, and no short line road in the country will pay better." Shoemaker wanted to build a twelve-mile spur line. Railroads weren't subject to the vagaries of the Potomac. They ran year-round and could carry exponentially more freight than the canal could.

Shoemaker noted that B&O Railroad president Robert Garrett had proposed this twelve-mile route several years before. Shoemaker noted that the quarry itself provided a lot of traffic for the canal—between six hundred and eight hundred wagonloads of stone each year. In the meantime, wagon teams would haul the stone to Gaithersburg or Boyds, the nearest railroad connections on the B&O's Metropolitan Branch that linked directly to Washington.

Another competing scheme briefly aired by the Harrisburg and Gettysburg Railroad was to build a railway from Gettysburg, Pennsylvania, to Frederick, Maryland, then along the Potomac through Seneca to Georgetown. This

would capture the C&O's traffic. One commentator mentioned, "The canal is a thing of the past, and Georgetown must have something to take its place, for we are now at the mercy of the Baltimore and Ohio, which has the power to charge exorbitant rates."

Such a competitive route was unacceptable to the B&O, as its business interests were threatened. The B&O had initially competed against the C&O, but the two had learned to work together. No railroad link was ever built to Seneca, as the B&O stepped in to rescue the bankrupt canal. The railroad took over operations of the C&O in 1890 and made repairs, reopening the canal in 1891. The B&O wasn't as interested in making the canal a success as keeping its valuable right-of-way out of the hands of its rivals.

The 1889 flood halted the flow of Seneca sandstone to Washington for almost two years, putting a crimp in many developers' plans. Quarry workers had to find alternative work during the closure. The town of Seneca was hard hit economically.

Unable to get its stone to market, the Potomac Red Sandstone Company went out of business. An auction was scheduled for December 20, 1890. This was the second time in a decade that the quarry was auctioned out of bankruptcy. "The five hundred acres described in the mortgage and to be sold include the celebrated Seneca quarries of red sand stone, with all the mills, machinery, trainways, cars, derricks, &c., necessary to operate said quarries on an extensive scale," the notice read in the *Evening Star*. The entire property was sold, including six canalboats. The buyer was George Mann of Baltimore, who won the quarry at auction for $30,900.

Mann was a contractor and stone supplier to the construction industry who likewise ran operations at the Cockeysville quarry. He was a Scotsman and president of the St. Andrews Society who would live until 1933. George Mann & Son reopened the quarry in 1891 as the Seneca Sandstone Company, reverting to its earlier name. The C&O reopened that spring, and Seneca redstone again flowed into Washington—and notably to Baltimore as well.

The quarry ownership transfer included the water lease from the C&O to power the mill. The canal directors (now staffed by B&O Railroad executives) attempted to cancel the twenty-year lease and replace it with a three-year agreement. If the Seneca Sandstone Company didn't sign the new lease, the C&O would shut off the water. The quarry sued and won its case in July 1892.

Two years after Mann took ownership of the Seneca quarry, a cryptic help wanted ad appeared in the *Evening Star* on December 13, 1892:

"BUILDERS—I WANT TO DEVELOP MY QUARRY. Seneca stone; can ship by water or rail. Will take part cash and part stock if company is started. Will permit full investigation. Property, &c., can be seen. Address QUARRY, Star office." This wasn't likely to be Mann, who had an efficient operation established, but rather a neighboring property (there were quarries all along this stretch of the Potomac).

A March 1896 advertisement in the *Cleveland Leader* for a quarryman read "WANTED—Energetic quarryman to take charge of red sandstone quarry and stone sawmill. Address Seneca Stone Co., 1416 North Charles St., Baltimore, Md.," near Penn Station. The man hired was George Goode, the last superintendent at the Seneca quarry. He was fifty years old in 1900 and living in the quarry master's house with his wife, Mary, and daughter, Jessie. The U.S. Census that year mentions that they had a boarder: Lorenzo Sager. He carved his name twice into the mill as "L. Sager"—once with the year 1901, the year the quarry closed. Sager was a twenty-eight-year-old carpenter from Virginia. He had been married three years before his first wife died. He is seen in a photo of the quarry workers with a big, bushy moustache and thick, dark hair. Behind him stands George Goode, his landlord and future father-in-law. Sager married Goode's daughter, Jessie, and the couple moved into their own home near Riley's Lock.

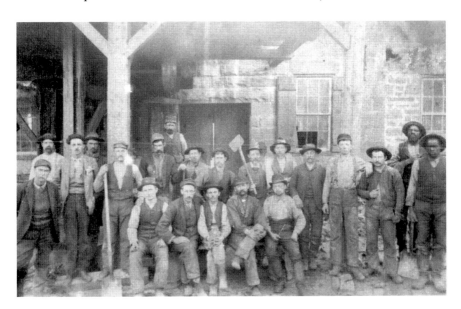

An 1890s photo of workers at the Seneca stonecutting mill. The man standing above the others is George Goode, the last superintendent. Immediately in front of him is Lorenzo Sager. *Courtesy of C&O Canal National Historical Park.*

Lorenzo Sager carved his name into the Seneca stonecutting mill in 1901. He worked at the quarry and was the son-in-law of its last superintendent, George Goode. *Courtesy of the author.*

There was a final burst of energy at the quarry under Mann's ownership. The year 1896 boded well, as the C&O Canal reopened after the winter and developers in Dupont Circle placed sandstone orders for many new town houses going up. The *Evening Star* wrote, "It is reported that there will be plenty of trade from Seneca, an extra demand for the stone quarried from that place having occurred. The quarry owners have large forces of men at work, getting a supply of stone on hand for the first shipment of the season." Some of the buildings erected include the Lab School of Washington "castle" (1895); the Riggs Place town houses, most built in 1898; and Edgar Kellogg's Adams Morgan development in 1899.

But a major problem doomed the quarry. The quality of the stone declined significantly as the stonecutters dug into the sides of the ancient riverbed, which was more layered and thus easily flaked. You see this firsthand along Riggs Place between Seventeenth and Nineteenth Streets—almost every house has Seneca redstone on the façade, but the stone is flaking away. Many homeowners have painted the sandstone to protect it from further weathering.

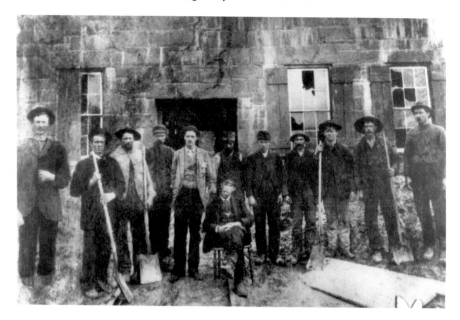

Workers gather in front of the stonecutting mill. Quarry superintendent George Goode is fourth from left. *Courtesy of Montgomery County Historical Society, Rockville, Maryland.*

The Portuguese Embassy's chancery at 2012 Massachusetts Avenue NW, built in 1898, has a red sandstone portico and supporting columns. The columns are full of small holes, possibly from Triassic-age shrimp burrows. No records indicate if this structure was made of Seneca redstone, but the color, year of construction and tiny holes are consistent with the quarry's final output.

There was a final reason for Seneca redstone's decline by the turn of the century: brownstone was no longer in vogue. The Victorian architectural styles—Gothic, French Second Empire, Italianate and Romanesque—had a good five-decade run, but these styles gave way to Colonial Revival and lighter-colored brick and stone. People no longer wanted rustic stone features and carvings on their homes. A savvy businessman, George Mann must have sensed the shift in fashion while also listening to complaints from developers about the declining quality of the stone.

Operations at the nearby Government Quarry likewise wound down. The quarry had supplied sandstone for Cabin John Bridge, as well as the dam just above Great Falls. Washington Aqueduct expanded the dam in the 1890s, using Seneca sandstone from the Government Quarry until 1893 and then shifting to more durable granite. Washington Aqueduct still provides much of the drinking water for the Washington area.

The Seneca quarry closed in 1901. There is no documentation about the quarry closing, as it went unrecorded in the newspapers. However, we know that the building permit records for Seneca sandstone stop in 1901, that the last newspaper articles mentioning Seneca structures to be built were published in 1901 and that quarry employee Lorenzo Sager carved his name on the mill that year—probably as a way of saying goodbye.

But, as it turned out, the quarry wasn't closed for good. The *Washington Times* reported in April 1904 that it was temporarily reopened to quarry rock for a new Crown Cork and Seal headquarters at 1501–1523 Guilford Avenue in Baltimore, the edge of the "burned out district" after the Great Baltimore Fire. This was the last building constructed with stone quarried directly from Seneca. Perhaps it was this company that left behind the dozens of boulders that the Smithsonian would sweep up in 1981 to build the Renwick Gate.

The town of Seneca slowly changed as it shifted its livelihood away from the canal and the quarry. Wilson Tschiffely purchased Seneca Mill in 1900, and his family operated it until it closed in 1931. Frederick Allnutt had been running a store along the C&O, but as canal traffic declined and the quarry closed, he built a new store along River Road. Allnutt's General Store was run by longtime employee Raymond Poole and was known as Poole's Store until its closure in 2011. The "quarry farm" was sold to Charles Allnutt and Thomas Darby in 1903. The Darbys in turn sold it to Eugenia and Harry Pierpoint in 1946.

The C&O Canal's days were numbered as well. The B&O Railroad ran the canal until the 1924 flood knocked out the canal for good. The C&O had operated for ninety-six years. The town of Seneca, long in decline, withered. Local resident Claude Owen later wrote, "Progress was the death of Seneca as a commercial center. Architectural tastes and designs changed, and with it the market for Seneca Stone, and about the turn of the century, the stone mill ceased operation." The Seneca quarry may have closed, but its story is far from over.

Chapter 9
Saving Seneca

The Seneca quarry closed in 1901, and the C&O Canal ceased operating after the flood of 1924. The water-powered mills along Seneca Creek shut down as larger industrial mills, powered by electricity, eclipsed them in volume and speed. Once a thriving commercial town, Seneca dwindled into a village, most of its laborers leaving for work elsewhere.

Abandoned by people, nature took over the quarry. Out of the barren site sprung up pawpaw and sycamore trees, the ubiquitous wild roses whose thorns cling to your clothes, various ivies (both poisonous and non-poisonous) and the occasional snake. If you consider the quarry preserved, then it is preservation by neglect.

During Prohibition, bootleggers operated stills in the quarries, and you can still find evidence of mash tuns and mason jars. It was a fabulous place to hide, as it was hidden and isolated and offered access to the Potomac should the bootleggers want to ship moonshine across the river—or escape. There is a shot-up 1930s-era car on the downhill slope to Bull Run.

Bootleggers were active in the Seneca community during Prohibition. The *Washington Post* reported the arrest of Isaac Willie after Montgomery County chief of police Alvie Moxley raided his three-hundred-gallon still on a Potomac River island in December 1928. Two others escaped by swimming to the Maryland shore. A year later, Moxley arrested Anteno Grimes after finding a ten-gallon still in his outhouse.

As the Great Depression gave way to the New Deal, historians were sent to document the Seneca area. In 1936, Historic American Buildings

Survey (HABS) photographer John Brostrup took a series of photographs documenting Seneca Aqueduct and nearby historic buildings like Montevideo and the overseer's house (now called River View). However, he neglected to photograph anything related to the quarry. Perhaps it was already forgotten, having closed decades before.

Seneca saw a different kind of resurgence in the 1950s, as the town became a weekend getaway for Washingtonians. The town only had about twenty-five permanent residents, according to the *Washington Star*, but hundreds of people descended on Seneca every summer weekend. Many people built cottages along the creek banks where they could put in their canoes, kayaks and motorboats, and Seneca became a popular fishing hole. Ray Riley, who was born in the lockhouse that bears his family name, rented boats. Next door was the Riverside Hotel (later the Seneca Hotel), built in the 1930s. The *Washington Star* reported in 1957, "It has only been a few years since chickens roamed through the hotel at Seneca. But things are different now as Seneca once more experiences boom times—the boom of water sports along

By the 1950s, Seneca Creek had become a weekend destination for many Washingtonians. *Courtesy of C&O Canal National Historical Park.*

the creek, river and canal." Finding parking became the main problem. In winter, people skated on the frozen creek.

Local resident Claude Owen wrote, "In my lifetime, I have seen the entire complexion of Seneca change from a hustling business community to one with practically no business but a number of small rather poorly kept summer cottages lining both sides of what was once a beautiful stream."

Seneca's past had receded from memory, but it wasn't entirely forgotten. In January 1968, the Smithsonian sent a team to survey the remains of the stonecutting mill. The team produced two diagrams: a map of the site and a plan of the building. They deposited the survey results with the HABS archive, located in the Library of Congress. Two of the surveyors, Paul Douglas and William Jones, then published an article that spring in the *Smithsonian Journal of History* documenting the quarry's role in building the Smithsonian Castle. This short article was the first history of the quarry ever written.

One of the Smithsonian surveyors, Mike Robbins, now lives in Leesburg, Virginia, where he edits *Military History* magazine. He was a graduate student

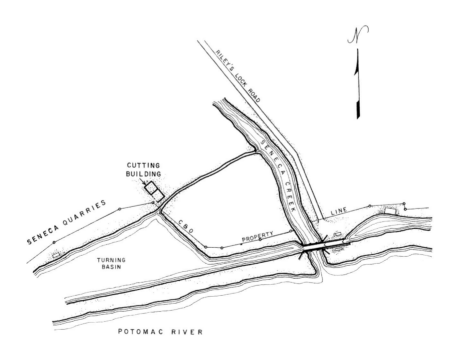

A map of the Seneca quarry and mill produced after the 1968 Smithsonian surveying expedition. *Courtesy of Library of Congress.*

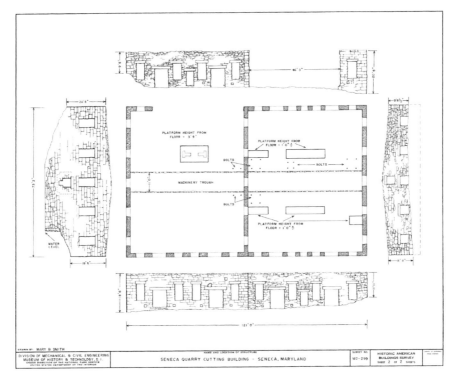

An architectural drawing of the stonecutting mill produced after the 1968 Smithsonian surveying expedition to Seneca. *Courtesy of Library of Congress.*

at George Washington University at the time, which had a liaison program with the Smithsonian. "It turned out to be a great thing for me—in fact, it turned out to be a career changer," Robbins explained. It was here that he met Robert Vogel, then the curator of engineering at the National Museum of American History. Vogel was fascinated with industrial sites and often took students to forgotten industrial places. "It was always very entertaining because Robert's an entertaining guy," Robbins said. "He has an amazing sense of looking at surviving ruins and being able to know or intuit the processes and why the way things looked. Traipsing around a site with him was an education in itself."

What does Robbins remember from the visit that cold January day in 1968? "Not much. I remember going there, and I can see in my mind's eye what the building looks like. I remember the rough structure of the building, the shape of the windows." He also remembers lots of poison ivy (some things haven't changed). "There's nothing like measuring everything to see how people built things. That kind of thing is pretty fantastic."

With the Seneca stonecutting mill finally documented for HABS, the quarry could now qualify to be on the National Register of Historic Places. It made the list in 1973—the year after Seneca Creek State Park was created.

THE KIPLINGERS AT MONTEVIDEO

For Christmas 1973, Austin Kiplinger published a small book titled *The How Not To Book of Country Life*, full of witty observations about his life and restoration of Montevideo, John P.C. Peter's residence. He included this fair warning:

> *Beware the owner of an old house. He is likely to be a bore on the subject of his infatuation. Having thus warned you, I should like to invite you, when you have time to spare, to come in and let me show you the before-and-after pictures of our old house, Montevideo. But if you do, don't say I didn't warn you. The owners of an old house can talk an arm off you, and he may even end up trying to get you down into the old cellar. But if you succumb, I'll show you some historic records and the cemetery out in the back field, and the old winter kitchen in the basement, and how the beams are put together with pegs, and all that.*

Austin's father, W.M. "Kip" Kiplinger, started the *Kiplinger Washington Letter* in 1923 and *Kiplinger's Magazine* in 1947, which is still published by the family today. He began collecting images from Washington's history in the 1920s. His son, Austin, and grandson, Knight, continued collecting Washingtoniana until they had amassed five thousand pieces of local history. In December 2011, the Kiplingers donated most of the collection to the Historical Society of Washington, D.C. It came in thirty-eight large boxes. "We are Washington history junkies," Knight told the *Washington Post*.

The Kiplingers have long been mindful of history. Austin and his wife, Gogo, purchased Montevideo and 150 acres in 1958. It had been abandoned for fifteen years, formerly owned by Congressman James Barnes and his wife, who had intended to fix the place up. The Kiplingers performed major renovations, and as Austin pointed out, you're never quite done with an old house.

I met Austin on a warm day in May 2012. He was ninety-three and drove himself to Montevideo. When he saw my car, a Ford Fiesta, he just

about howled with glee. "I loved my Fiesta!" he announced (his was a 1980 model—the only year that they were made for the American market before returning in 2010). He was friendly, spry, witty and quite mobile. He wore no glasses. He was as active as someone four decades younger.

The Kiplingers added to their property over time until they owned most of the land between Montevideo Road and Partnership Road south of Seneca Creek, about 400 acres in all. Austin was involved in creating the Seneca Historic District in 1978, a nationally recognized 3,850-acre district that includes the quarry and many historic buildings around Seneca. He also put most of the acreage of Montevideo under a conservation easement so that it can never be developed.

The Kiplingers love holding square dances in their restored barn. Every May they host the Potomac Hunt Races on their farm, an annual steeplechase that draws large crowds of horse-racing lovers. Their farm is also the home of the Seneca Valley Pony Club.

MRS. PIERPOINT AND THE BARN TRAGEDY

Harry Pierpoint and Eugenia Pierpoint bought a large swath of property around Seneca in 1946 that included the overseer's house, the quarry master's house and the stonecutting mill—what was known as the Quarry Farm. The Pierpoints never lived in Seneca; rather, they resided in Bethesda and leased their land to tenant farmers, an African American family, the Jacksons. The Jacksons moved into the quarry master's house and farmed the land.

Harry Pierpoint died in 1952, and Eugenia continued owning the farm. Though she donated most of her land to Maryland in 1972 to form the southern end of Seneca Creek State Park, she kept twenty-five acres north of River Road, including the Montevideo overseer's house (River View). Just north of the overseer's house was a Greek Revival barn with a projecting stone portico. "It was a unique barn in all of America—a masterpiece," Knight Kiplinger said, but it no longer exists. This was the barn that James Renwick and David Dale Owen had noted in their reports to the Smithsonian Building Committee after visiting the Seneca quarry in March 1846.

On May 10, 1975, three busloads of Smithsonian resident associates drove up to Montevideo to see the Kiplinger farm. Two hours later, a bulldozer began leveling the barn on orders from Eugenia Pierpoint. Austin Kiplinger

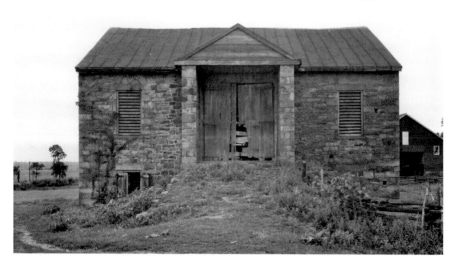

The Greek Revival barn near Montevideo that Eugenia Pierpoint demolished in 1975. *Courtesy of Library of Congress.*

and a neighbor, Jim Mann from Rocklands, rushed over to stall the bulldozer operator. Kiplinger then called Mrs. Pierpoint to ask her to stop. She told him, "My lawyers tell me the barn is a liability. Children could be injured playing in it." The bulldozer continued its destruction until the structure was leveled. It dug a pit, pushed the redstone blocks into it and then covered it with earth.

Austin Kiplinger later purchased Eugenia Pierpoint's farmland, including the barn remnants. He remarked, "I remember her saying in her quavering voice," and raising his voice several octaves to imitate her, "'I left the stones buried for you if you ever want to use them.'" He shook his head in dismay.

The destruction of the historic barn remains a sore point among those who live in Seneca. It gave impetus to create the Seneca Historic District in 1978 to prevent such future tragedies. But the overseer's house and slave quarters are still there, critical buildings of the historic district that are now protected from demolishment. A similar barn, minus the Greek Revival portico, stands at East Oaks (21524 Whites Ferry Road in Poolesville), built around 1829.

THE RENWICK GATE AND
SMITHSONIAN RESTORATION

James Goode served as the Smithsonian Castle curator from 1970 to 1987. During this time, he ensured that every aspect of the building was photographed and archived. His successor, Rick Stamm, maintains this collection. "James Goode did a great job making sure everything was photographed," he said. Goode worked for legendary secretary Dillon Ripley, who led the Smithsonian from 1964 to 1984 during its greatest years of expansion. One of the major projects was to convert a parking lot on the grounds south of the castle along Independence Avenue into two museums: the African Art Museum and the Sackler Gallery. They are brilliantly situated, built vertically into the ground and covered with the Enid A. Haupt Garden—a rooftop garden at street level.

Goode wanted to add a gate to the garden, part of James Renwick's vision for the castle that had never been executed. He found a Renwick drawing of a four-posted gate that was published in Robert Dale Owen's *Hints on Public Architecture* in 1849. He also used the Renwick-designed gates at Oak Hill Cemetery as a real-world model. Stone carver Clift Seferlis said, "They were going on the measurements of the Oak Hill Cemetery gate—not to be exact replicas, but similar."

Goode now had a design for the gate, and Ripley approved the addition to the garden. But where to find original Seneca sandstone? Goode's friend Knight Kiplinger mentioned that there were a number of pre-cut boulders sitting in the quarry unused. "Since the Seneca quarry was a national site, we couldn't just take them out," Goode noted. It took conversations with several cabinet secretaries before they had permission. The Smithsonian retrieved a number of boulders from the quarry in 1981 but soon learned why they were left behind: their quality was defective. Half of the stone was discarded.

Fortunately, a source of Seneca sandstone came forth the following year as the D.C. Jail was being demolished. "It was fairly easy getting the stone," Goode said. "They were going to bulldoze it and throw it in some ravine, so they didn't care." The Smithsonian retrieved much of the jail's façade, as it was original Seneca red sandstone quarried in the 1870s.

Goode traded for the rest of the sandstone that he needed for the Renwick Gate. The Adolf Cluss–designed Army Medical Museum on the National Mall was demolished to make room for the Hirshhorn Museum. Goode had retrieved several cast-iron columns, and he traded these for Seneca redstone

from the wall surrounding the Sumner School (another Cluss building), which was then undergoing renovation.

With three sources of original Seneca sandstone, the Smithsonian could not only build the Renwick Gate but also construct two small huts near the castle. Stone carver Constantine Seferlis built a plywood mock-up to scale the gates appropriately before carving the sandstone. Dennis Rude cut the stone blocks into shape before Seferlis began sculpting them.

Seferlis came to the United States from Sparta, Greece, in 1957. Finding his services much in demand, he worked on a large number of stone-carving projects, including the National Cathedral. James Goode hired him around 1980 to restore the statue of St. Dunstan. By this time, the castle was covered with ivy. "That just wreaked havoc," curator Rick Stamm remarked, as ivy can pry its way several feet into rock and allow in damaging moisture. Seferlis insisted that the ivy be removed. He then worked on the south tower window restoration, followed by the Renwick Gate.

The Enid A. Haupt Garden and Renwick Gate were dedicated on May 21, 1987. There was one problem: Mrs. Haupt didn't like the finials that Seferlis carved atop the four gateposts—she thought them too phallic—so the "fallacies" (as Seferlis's son Clift called them) were removed but kept in storage. About a month after she died in 2005, Castle curator Rick Stamm ordered the finials reinstalled on the gateposts. Constantine Seferlis died the same year.

As the Seneca quarry is permanently closed, the Smithsonian Castle has had to look elsewhere for replacement redstone for ongoing restoration, including reusing stone from other structures like the D.C. Jail. The Smithsonian has stockpiled sandstone at its Paul E. Garber Facility in Suitland, Maryland (also known as Silver Hill). Restoration work never stands still on the castle. At its current replacement rate of twenty-five to thirty stones per year, the jail stockpile will be used up within five to ten years (as of 2012), according to Clift Seferlis. In addition, his father Constantine retrieved an enormous supply of redstone, also stored at the Garber Facility, from a demolished bridge over the Connecticut River near Holyoke, Massachusetts. "The Smithsonian has about two hundred years of supply from the Massachusetts bridge," Clift concluded.

Why does Seneca redstone need replacing? "The problem with sandstone is that it's got layers," said Rick Stamm. "When the layering is lined up vertically, moisture gets in and peels away the stone over time." Castle preservationists experience fewer problems with stones with horizontal layering. Stones can be resurfaced with a hammer and chisel or replaced

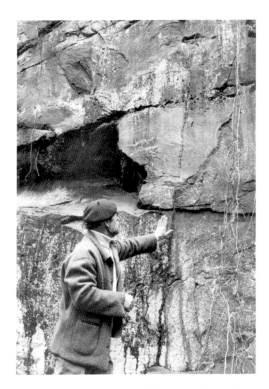

Sculptor Constantine Seferlis examines the Seneca quarry wall during the Smithsonian's 1981 expedition to retrieve stone for the Renwick Gate. *Courtesy of Smithsonian Institution Castle Collection.*

Constantine Seferlis chisels at a boulder in the Seneca quarry. *Courtesy of Smithsonian Institution Castle Collection.*

Constantine Seferlis numbers discarded boulders for retrieval in the Seneca quarry. *Courtesy of Smithsonian Institution Castle Collection.*

The selected boulders are loaded onto a flatbed for shipment to Washington. *Courtesy of Smithsonian Institution Castle Collection.*

Right: Constantine Seferlis builds a mock-up for the Smithsonian's Renwick Gate. *Courtesy of Smithsonian Institution Castle Collection.*

Below: The Smithsonian Castle and Renwick Gate mock-up taken from the Forrestal Building. *Courtesy of Smithsonian Institution Castle Collection.*

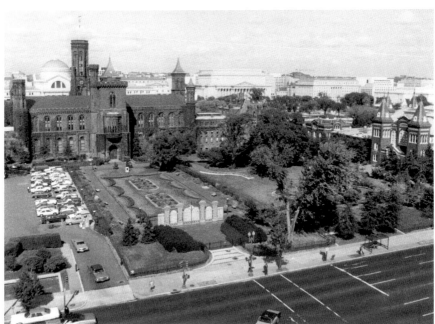

Second-generation stone carver Clift Seferlis restores a stone on the Smithsonian Castle. *Courtesy of the author.*

entirely. "That's where it gets fun," Clift Seferlis said. Red sandstone "is a little unpredictable. It has a grain to it, unlike limestone or marble. The one thing Seneca does—it holds its edge so beautifully." He added, "It's a fantastic material to work with. Very dense. It's a beautiful process to watch it get old."

Seneca's Future

The Seneca quarry could have been lost entirely. In the 1950s, the U.S. Army Corps of Engineers proposed a series of sixteen major dams along the Potomac River watershed for flood control and storing drinking water for the Washington area. One dam was proposed for just above Great Falls at River Bend, but after public opposition, the corps shifted the proposed dam location four miles to the west to Blockhouse Point in 1962. This eighty-four-foot-high dam would create Big Seneca Lake, flooding thirty-one miles of

the Potomac all the way to Brunswick, Maryland. That entire stretch of the C&O Canal would be under water, as would part of Seneca Creek, the town of Seneca and the Seneca quarry. Public opposition was fierce. President Lyndon Johnson instead proposed a national cleanup of the Potomac, shelving the Seneca dam in 1967. Only two of the dams were ever built: one at Bloomington High on the Allegheny Plateau and the Little Seneca Dam on Seneca Creek near Germantown.

Seneca won a brief reprieve before nature nearly destroyed the town. In September 1971, a torrential thunderstorm dumped up to eleven inches of rain on Montgomery County, and much of that water drained into Seneca Creek. The stream is normally about three feet deep, but it flooded to more than twelve feet. About fifty cottages and homes along the creek were heavily damaged. So much debris was carried downstream that, when it reached Seneca Aqueduct, the debris dammed the creek, exacerbating the flooding. The *Washington Star* reported: "The pressure against the aqueduct—which was built with interlocking stone without mortar—finally gave way. 'It was like someone pulled the plug on a bathtub full of water,' Mrs. [Francis] Poole said, recalling the precipitous drop of the creek level when the portion of the aqueduct collapsed." She and her husband, Raymond, ran Poole's Store.

Seneca Aqueduct lost one of its three arches in the collapse, giving it its gapped-tooth appearance. The National Park Service shored up the aqueduct with steel beams and cement and built a wooden walkway to carry the towpath over the missing section. It was an ugly fix-it job. The beams trap tree branches and trunks, further endangering the aqueduct. The stones from the collapsed section were gathered up and now lie along the towpath in a pile.

As Seneca lay along a known flood plain, Montgomery County refused to allow homeowners to rebuild. That signaled the end of the resort town. With the destruction caused by the thunderstorm, Maryland accelerated plans to create a state park based on Seneca Creek.

Eugenia Pierpoint donated about 270 acres of land on both sides of River Road in March 1972 (according to the deed filed with the state, she technically sold it for ten dollars), which then became part of Seneca Creek State Park. The state acquired the land to protect the watershed during the major effort to clean up the Potomac River begun by President Johnson. Most of the land was south of River Road and included the quarry farm, the quarry master's house, the stonecutting mill and the schoolhouse.

Just three months after the state purchased the land, Hurricane Agnes swept through in June 1972, causing further damage to what was left of

Seneca. The town never recovered—many of the buildings were demolished, and their remnants were carted away. Few buildings were ever rebuilt. Agnes was, at that time, the costliest storm in American history. The Seneca Hotel closed and became an alcohol and drug treatment center but was demolished in the 1990s. For the nation's bicentennial in 1976, there was an effort to create a visitor park at the quarry, but nothing came of it. Today there is very little left of Seneca.

Montgomery County established its Agricultural Reserve in 1980, enacting a minimum of twenty-five-acre zoning in the western third of the county to minimize development and protect farmland. It was farsighted. The Washington suburbs have been on a steady march outward since World War II, devouring farmland and turning commutes into some of the worst in the country.

Across the Potomac River in Virginia, Loudoun County has developed into car-oriented suburbs with large housing developments. There are some who call for a second Beltway and another river crossing to make it easier for commuters. Such a route would have to traverse the Agricultural Reserve, and that would in turn create tremendous pressure to allow greater suburban development. Build a road, and people will want to build along it. Montgomery County had the wisdom to set aside this land as farmland, and it needs to remain farmland forever.

Western Montgomery County is in danger of becoming a bedroom community anyway. As I left Seneca one evening during rush hour, I traveled freely eastward on River Road—but witnessed a terminally long line of cars traveling in the opposite direction when returning home from work. It will get far worse if a Potomac crossing is ever built in this region.

A Seneca Quarry Visitor Park

The good news is that the Seneca quarry is entirely preserved within parkland, so there is no risk of it being developed. The aqueduct, cemetery, quarry and turning basin are part of C&O Canal National Historical Park, while the stonecutting mill, quarry master's house and schoolhouse are all within Seneca Creek State Park. What is needed now is preservation, restoration and public awareness.

"We know the significance of the site," remarked Charlie Mazurek of the Maryland Department of Natural Resources. "It's something we'd love to

preserve, but we've lacked the funding." But if the funding could be found, that would change everything. Seneca is already a popular destination. Many fishers and kayakers put into Seneca Creek to enjoy the Potomac, and countless cyclists and walkers explore the C&O towpath. Most pass by without ever realizing the Seneca quarry is just a stone's throw away. "It's one of those sites that's out in the woods, sitting there waiting to be explored and interpreted," Mazurek said. "It's one of those that I'd like to see something done to."

The C&O Canal stretches along the Potomac shoreline, but behind it is a five-mile-long natural buffer zone that Maryland largely owns, from Blockhouse Point to McKee-Beshers Wildlife Management Area. The state leases out part of the land to farmers and opens it to hunters, but it could also adapt the land into a recreation area with hiking paths and interpretive trails. "To me, it's painfully obvious what they should do," said Bob Albiol, who restored and lives in the quarry master's house. "They could design the world's greatest park here."

Besides funding, what would it take to create a Seneca quarry visitor park?

The vegetation needs to be thinned so visitors can enter the quarry. A herd of goats could remove much of the dense vegetation in a matter of days—and without using herbicides.

The Seneca Aqueduct needs to be repaired and restored and an active program created to remove driftwood that may clog or damage the structure.

Likewise, the stonecutting mill needs shoring up. It isn't necessary or practical to fully restore the building but to simply stabilize it so it doesn't decay further. Some of the trees nearby will need to be removed, lest their collapse damage the mill.

A key feature of the visitor park would be a loop trail, complete with interpretive signs. It should start at Seneca Aqueduct, where most people park. It would then lead to the stonecutting mill, through the quarry, up to the quarry master's house and then down to the Bull Run quarry where the Smithsonian Castle was cut from the cliff side. It could continue along to the College Quarry and Peter's 1837 quarry. It would end at the quarry cemetery, where so many workers have their final rest, and then loop back to Seneca Aqueduct—possibly by the C&O Canal towpath if a footbridge over the canal were built.

And the quarry master's house? Bob Albiol sees a new role for the building: "This will be the perfect place for a museum of the quarry and the canal." That dream may be some time away, but for now it is good that someone lives in it, as every building needs someone to care for it.

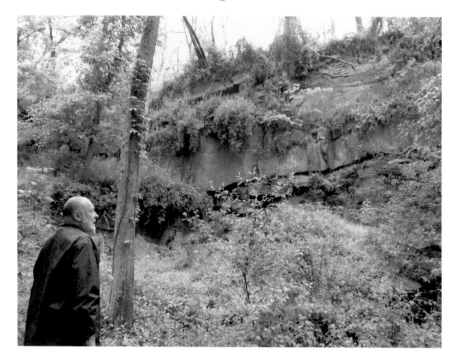

Bob Albiol looks up at the Seneca quarry. *Courtesy of the author.*

Creating a Seneca quarry visitor park will require cooperation between the C&O Canal National Historical Park and Seneca Creek State Park to create a visitor experience that draws in hikers, historians and naturalists. It can be done. A great example is nearby. In 2010, Virginia's Stafford County opened Government Island, a public park that includes the Aquia quarry that Pierre L'Enfant purchased for the federal government in 1791. Locals have embraced the park, and it is a fascinating place to witness history and enjoy the scenery and wildlife.

The future of the Seneca quarry is in doubt. Nature has taken over. The stonecutting mill is decaying, and it is a question of time before the building collapses and looters haul the stones away. Seneca Aqueduct can't stay forever shored up with a missing arch. These structures need care, they need preservation and they need restoration. It would be a shame to lose something so important to Washington-area history simply because of neglect. A visitor park could change that. Bob Albiol concluded, "This could be the most important contribution to preservation of history in this area, bar none."

Sources

Auslander, Mark. "Enslaved Labor and Building the Smithsonian: Reading the Stones." *Southern Spaces*, December 12, 2012.

Baltimore Sun. "The Baltimore Club," April 6, 1887.

———. "The Congressional Investigations: The Seneca Stone Ring," March 18, 1876.

———. "Freedman's Bank Investigation," January 21, 1880.

———. "Freedman's Saving Bank: Its Bad Management and Condition," April 27, 1874.

———. "Freedmen's Savings Bank," May 20, 1876.

———. "From Gen. Banks' Division," November 16, 1861.

———. "The Great Falls Company: Why a Defunct Corporation Has Been Revived," April 23, 1883.

———. "Gymnasium in New Western High School Building," November 16, 1895.

———. "A Noble Structure: New Congressional Library Will Be Opened to the Public Today," November 1, 1897.

———. "Patriarch of Scotsmen Here Dies After Ten-Day Illness," December 21, 1933.

———. "Railroad Projects in Montgomery County," July 4, 1889.

———. "The Rebel Retreat—Later," July 15, 1864.

———. "Sale of the Seneca Stone Quarries," April 24, 1882.

———. "Seneca Sandstone Company: Decision in Its Favor by Judge Alvey at Hagerstown," July 13, 1892.

———. "The Seneca Sandstone Company," November 21, 1874.

———. "The Seneca Stone Company—Renomination of Major Griswold—The Patent Commissionership," January 19, 1876.

Boyd, T.H.S. *The History of Montgomery County, Maryland, from Its Earliest Settlement in 1650 to 1879*. Baltimore: Regional Publishing Company, 1968.

Carper, Elsie. "Report Puts High Dam at Seneca." *Washington Post*, May 12, 1962.

Cavicchi, Clare Lise. *Places from the Past: The Tradition of Gardez Bien in Montgomery County, Maryland*. Silver Spring: Maryland-National Capital Park and Planning Commission, 2001.

Chesapeake and Ohio Canal Company (1828–1924). "Deeds and Other Records Concerning Land Titles, 1828–1878." Record Group 79, National Archives, Washington, D.C.

———. "Record of Boat Registrations, 1851–1874." Record Group 79, National Archives, Washington, D.C.

———. "Reference to Land Titles, 1829–1868." Record Group 79, National Archives, Washington, D.C.

———. "Register of Tolls Collected at Georgetown, 1845–1854." Record Group 79, National Archives, Washington, D.C.

Cleveland Leader. "Wanted—Energetic Quarryman," March 12, 1896.

Cranford, John R. "Seneca: Tiny Village of 20 Homes Fights Floods, State Takeover." *Sentinel*, August 30, 1979.

Cutchin, Janine Basile. "The Quarry Master's House: Seneca, Maryland." Master's thesis, 1978.

Daily Albany Argus. "Odds and Ends," October 21, 1871.

———. "The Seneca Redstone Quarry," May 17, 1871.

Daily National Intelligencer. "Local Matters," June 16, 1855.

———. "New Mills at Seneca Falls," February 20, 1869.

———. "150 Dollars Reward," July 20, 1831.

———. "Seneca Stone for the Treasury Building," May 12, 1837.

Davies, William E. *The Geology and Engineering Structures of the Chesapeake and Ohio Canal*. N.p.: C&O Canal National Historical Park, 1999.

DeFerrari, John. *Lost Washington, D.C.* Charleston, SC: The History Press, 2011.

Douglas, Paul H., and William K. Jones. "Sandstone, Canals, and the Smithsonian." *Smithsonian Journal of History*, no. 3 (Spring 1968).

Duncan, Russell, ed. *Blue-Eyed Child of Fortune: The Civil War Letters of Colonel Robert Gould Shaw*. Athens: University of Georgia Press, 1992.

Evening Star. "Alexandria. The Municipal Stone Yard," March 10, 1892.

———. "Auction Sales. Future Days. Trustees Sale of Valuable Mill Property," June 2, 6, 9, 12, 1900.

———. "Boyd's & Vicinity," February 2, 1903.

———. "Builders—I Want to Develop My Quarry," December 13, 1892.

———. "Contemplated Improvements," September 13, 1867.

———. "Deplorable Disaster," January 24, 1865.

———. "The District Volunteers," June 17, 1861.

———. "The Enemy Crossed Over into Maryland," June 11, 1863.

———. "The Fire at the Smithsonian Institution," January 25, 1865.

———. "For Sale," April 27, 1864.

———. "The Freedmen's Savings Bank," May 19, 1876.

———. "Georgetown Affairs," September 12, 1862.

———. "Getting Even," December 2, 1884.

———. "The Late Raid into Maryland," June 12, 1863.

———. "Local Notes Concerning Persons and Things," March 7, 1896.

———. "Mrs. Shields' New Residence," October 20, 1888.

———. "News from Rockville. Sale of the Seneca Sand Stone Quarries," December 23, 1892.

———. "Oak Hill Cemetery," September 22, 1869.

———. "Proposals for Inclosures and Lodges for National Cemeteries at Washington, D.C., Arlington and Alexandria, VA," August 10, 1870.

———. "Public Sale of Valuable Improved Quarries, Real Estate and Personal Property," November 29, December 12, 15, 1890.

———. "Sale of the Seneca Stone Quarries," April 24, 1882.

———. "The Seneca Stone Investigation," March 25, 1872.

———. "Wanted—At Seneca Quarries, Laborers and Quarrymen," July 22, 1871.

———. "Wanted—At Seneca Quarry, 50 Experienced Quarrymen (Colored)," July 16, 1873.

Ewing, Heather. *The Lost World of James Smithson: Science, Revolution, and the Birth of the Smithsonian*. New York: Bloomsbury, 2007.

Frank Leslie's Illustrated Newspaper. "The Seneca Stone Quarry," April 20, 1872.

Gay, Lance. "Flood Sequel: No New Homes." *Washington Star*, September 23, 1971.

Gay, Lance, and Michael Anders. "Floods, Twister Cut a $5 Million Swath." *Washington Star*, September 13, 1971.

Geneva Gazette (NY). "Can It Be True?" September 1, 1871.

Goode, James M. *Best Addresses*. Washington, D.C.: Smithsonian, 2003.

———. *Capital Losses: A Cultural History of Washington's Destroyed Buildings*, 2nd ed. Washington, D.C.: Smithsonian, 2003.

———. *Washington Sculpture: A Cultural History of Outdoor Sculpture in the Nation's Capital*. Baltimore: Johns Hopkins University Press, 2008.

Haines, Ronald E. "$3 Million Flood Damage Here." *Sentinel*, September 16, 1971.

Harrisburg Patriot. "A Colossal Statue of Grant," October 26, 1871.

———. "Sandstone President: Grant a Stockholder in the Seneca Quarry," October 3, 1871.

High, Mike. *The C&O Canal Companion*, updated edition. Baltimore: Johns Hopkins University Press, 2000.

Historic American Building Survey. "Halcyon House (Stoddert)." HABS No. DC-69, October 22, 1959.

———. "Oak Hill Cemetery Chapel." HABS No. DC-172, September 1969.

———. "The Renwick Gallery." HABS No. DC-49/DC-140, March 1, 1971.

Historic American Landscape Survey. "St. Elizabeths Hospital West Campus." HALS No. DC-11.

Hurley, William N., Jr. *1850 Census of Montgomery County, Maryland*. Bowie, MD: Heritage Books, 1998.

———. *1860 Census of Montgomery County, Maryland*. Bowie, MD: Heritage Books, 1998.

———. *1870 Population Census of Montgomery County, Maryland*. Bowie, MD: Heritage Books, 1999.

———. *1880 Population Census of Montgomery County, Maryland*. Bowie, MD: Heritage Books, 1999.

———. *1900 Population Census of Montgomery County, Maryland*. Bowie, MD: Heritage Books, 2000.

Jacobs, Charles T. *Civil War Guide to Montgomery County, Maryland*. Rockville, MD: Montgomery County Historical Society, 2011.

Jonas, Jack. "Summering at Seneca." *Washington Star*, September 1, 1957.

Journal and Reports of the Building Committee of the Smithsonian Institution, from 1847 to 1868, published in *Smithsonian Miscellaneous Collections* 18. Washington, D.C.: Smithsonian Institution, 1880.

Kelly, John. "Kiplinger, an Old Washington Company, Makes a Gift of Old Images." *Washington Post*, January 16, 2012.

Kephart, Mary Ann. "Greek Revival Tragedy." *Gaithersburg Gazette*, May 22, 1975.

Kernan, Michael. "Clippers Along the C&O Canal." *Washington Post*, June 8, 1977.

Kim, Patricia. "Maryland Deals for Restoration." *Washington Post*, July 13, 2002.

Kiplinger, Austin H. *The How Not To Book of Country Life*. Montevideo, MD: 1973.

Luther Place Memorial Church. "Minutes of Building Committee." July 18, 1870.

Lynch, Sean. "The Vermiculation of Washington D.C." Transformer gallery exhibit, June, 2012.

McDaniel, George W. *Black Historical Resources in Upper Western Montgomery County*. Barnesville, MD: Sugarloaf Regional Trails, 1979.

Mosby, John S. *Mosby's War Reminiscences and Stuart's Cavalry Campaigns*. New York: Dodd, Mead and Company, 1887.

Mumford, Lewis. *The Brown Decades: A Study of the Arts in America 1865–1895*. New York: Dover Publications, 1931.

National Register of Historic Places, Seneca Quarry, Seneca, Montgomery County, Maryland, National Register # 17-52.

National Republican. "United States Marshal's Sale of Canal Boats, Seneca Stone, &c.," December 21, 1874.

New York Times. "General Grant's Seneca Quarry Stock," November 2, 1871.

Owen, Claude W. *Seneca, Once a Commercial Center*. Rockville, MD: Montgomery County Historical Society, 1970.

Owen, Robert Dale. *Hints on Public Architecture*. New York: Putnam, 1849.

Peck, Garrett. *The Potomac River: A History and Guide*. Charleston, SC: The History Press, 2012.

Pohl, Robert. "The Old Jail: The Long, Unhappy Saga of the DC Jail." *The Hill Rag*, August 2010.

Potomac Red Sandstone Company brochure. Washington, D.C.: Gibson Brothers, printers, 1884.

Ramage, James A. *Gray Ghost: The Life of Col. John Singleton Mosby*. Lexington: University Press of Kentucky, 1999.

Rathner, Janet Lubman. "Chips Off an Old Sandstone Cutter's Block." *Washington Post*, October 28, 2006.

"Records of the Office of Public Buildings and Public Parks of the National Capital, 1790–1992." Record Group 42, National Archives, Washington, D.C.

Rhees, William J., ed. *The Smithsonian Institution: Journals of the Board of Regents, Reports of Committees, Statistics, Etc*. Washington, D.C.: Smithsonian Institution, 1879.

Rhodes, Robert Hunt, ed. *All for the Union: The Civil War Diary and Letters of Elisha Hunt Rhodes*. New York: Orion Books, 1991.

Russell, Charles Wells, ed. *The Memoirs of Colonel John S. Mosby*. Bloomington: Indiana University Press, 1959.

Scott, Pamela, and Antoinette J. Lee. *Buildings of the District of Columbia*. New York: Oxford University Press, 1993.

Select Committee on Freedman's Bank. *Index to Reports of Committees of the House of Representatives for the First Session of the Forty-Fourth Congress, 1875–1876*, Congressional Edition, Volume 1710.

Seneca Sandstone Company. "Seneca Stone Sustained!" Pamphlet, 1874.

Sentinel. "LBJ Plan Rules Out High Dam," February 2, 1967.

———. "Popularity of Seneca Creek Begins to Soar," June 4, 1959.

———. "Seneca Quarries, Farm in Montgomery Co., MD," April 21, 1882.

Simon, John Y., ed. *The Papers of Ulysses S. Grant, Volume 21: November 1, 1870–May 31, 1871*. Carbondale: Southern Illinois University Press, 1998.

———. *The Papers of Ulysses S. Grant, Volume 22: June 1, 1871–January 31, 1872*. Carbondale: Southern Illinois University Press, 1998.

Snyder, Timothy R. *Trembling in the Balance: The Chesapeake and Ohio Canal During the Civil War*. Boston: Blue Mustang Press, 2011.

Stamm, Richard E. *The Castle: An Illustrated History of the Smithsonian Building*, 2nd ed. Washington, D.C.: Smithsonian Books, 2012.

Sween, Jane C. "A History of Dawsonville and Seneca, Montgomery County, Maryland," Montgomery County Historical Society, 1993.

United States War Department. *War of the Rebellion: A Compilation of the Official Records of the Union and Confederate Armies*, Part II: Reports. Washington, D.C.: Government Printing Office, 1889.

Unrau, Harlan D. *Historic Resource Study: Chesapeake & Ohio Canal*. Hagerstown, MD: U.S. Department of Interior, 2007.

Washington Post. "Architects Are Kept Busy," June 4, 1893.

———. "Congressional Investigations," February 2, 1880.

———. "Death of John L. Kidwell," February 17, 1885.

———. "The Freedmen's Bureau Swindle: Senator Bruce Presents the Matter in Its True Light," April 4, 1879.

———. "Laying the Corner-Stone of the Smithsonian Institute," May 3, 1847.

———. "Men Who Build Houses: They Are Kept Very Busy at Present," January 27, 1889.

———. "A New Home for S.S. Cox," April 3, 1887.

———. "A New Railroad Proposed," June 13, 1889.

———. "Policemen Raid Island for Liquor; Man Seized," December 12, 1928.

———. "Still and Alleged Liquor Seized in Raid on Home," December 17, 1929.

———. "Surveyed on the Ice: The Secret History of the Kidwell Claim Published for the First Time," February 19, 1885.

———. "Symptoms of Grantism," February 5, 1879.

———. "They Want a Railroad," September 16, 1889.

———. "Trustees' Sale of the 'Seneca' Quarries and Farm in Montgomery Co., Md.," advertisement, April 3, 12, 14, 17, 19, 20, 1882.

Washington Times. "News from Boyds," April 13, 1904.

———. "News from Boyds," April 29, 1904.

Mumford, Lewis. *The Brown Decades: A Study of the Arts in America 1865–1895*. New York: Dover Publications, 1931.

National Register of Historic Places, Seneca Quarry, Seneca, Montgomery County, Maryland, National Register # 17-52.

National Republican. "United States Marshal's Sale of Canal Boats, Seneca Stone, &c.," December 21, 1874.

New York Times. "General Grant's Seneca Quarry Stock," November 2, 1871.

Owen, Claude W. *Seneca, Once a Commercial Center*. Rockville, MD: Montgomery County Historical Society, 1970.

Owen, Robert Dale. *Hints on Public Architecture*. New York: Putnam, 1849.

Peck, Garrett. *The Potomac River: A History and Guide*. Charleston, SC: The History Press, 2012.

Pohl, Robert. "The Old Jail: The Long, Unhappy Saga of the DC Jail." *The Hill Rag*, August 2010.

Potomac Red Sandstone Company brochure. Washington, D.C.: Gibson Brothers, printers, 1884.

Ramage, James A. *Gray Ghost: The Life of Col. John Singleton Mosby*. Lexington: University Press of Kentucky, 1999.

Rathner, Janet Lubman. "Chips Off an Old Sandstone Cutter's Block." *Washington Post*, October 28, 2006.

"Records of the Office of Public Buildings and Public Parks of the National Capital, 1790–1992." Record Group 42, National Archives, Washington, D.C.

Rhees, William J., ed. *The Smithsonian Institution: Journals of the Board of Regents, Reports of Committees, Statistics, Etc.* Washington, D.C.: Smithsonian Institution, 1879.

Rhodes, Robert Hunt, ed. *All for the Union: The Civil War Diary and Letters of Elisha Hunt Rhodes*. New York: Orion Books, 1991.

Russell, Charles Wells, ed. *The Memoirs of Colonel John S. Mosby*. Bloomington: Indiana University Press, 1959.

Scott, Pamela, and Antoinette J. Lee. *Buildings of the District of Columbia*. New York: Oxford University Press, 1993.

Select Committee on Freedman's Bank. *Index to Reports of Committees of the House of Representatives for the First Session of the Forty-Fourth Congress, 1875–1876*, Congressional Edition, Volume 1710.

Seneca Sandstone Company. "Seneca Stone Sustained!" Pamphlet, 1874.

Sentinel. "LBJ Plan Rules Out High Dam," February 2, 1967.

———. "Popularity of Seneca Creek Begins to Soar," June 4, 1959.

———. "Seneca Quarries, Farm in Montgomery Co., MD," April 21, 1882.

Simon, John Y., ed. *The Papers of Ulysses S. Grant, Volume 21: November 1, 1870–May 31, 1871*. Carbondale: Southern Illinois University Press, 1998.

———. *The Papers of Ulysses S. Grant, Volume 22: June 1, 1871–January 31, 1872*. Carbondale: Southern Illinois University Press, 1998.

Snyder, Timothy R. *Trembling in the Balance: The Chesapeake and Ohio Canal During the Civil War*. Boston: Blue Mustang Press, 2011.

Stamm, Richard E. *The Castle: An Illustrated History of the Smithsonian Building*, 2nd ed. Washington, D.C.: Smithsonian Books, 2012.

Sween, Jane C. "A History of Dawsonville and Seneca, Montgomery County, Maryland," Montgomery County Historical Society, 1993.

United States War Department. *War of the Rebellion: A Compilation of the Official Records of the Union and Confederate Armies*, Part II: Reports. Washington, D.C.: Government Printing Office, 1889.

Unrau, Harlan D. *Historic Resource Study: Chesapeake & Ohio Canal*. Hagerstown, MD: U.S. Department of Interior, 2007.

Washington Post. "Architects Are Kept Busy," June 4, 1893.

———. "Congressional Investigations," February 2, 1880.

———. "Death of John L. Kidwell," February 17, 1885.

———. "The Freedmen's Bureau Swindle: Senator Bruce Presents the Matter in Its True Light," April 4, 1879.

———. "Laying the Corner-Stone of the Smithsonian Institute," May 3, 1847.

———. "Men Who Build Houses: They Are Kept Very Busy at Present," January 27, 1889.

———. "A New Home for S.S. Cox," April 3, 1887.

———. "A New Railroad Proposed," June 13, 1889.

———. "Policemen Raid Island for Liquor; Man Seized," December 12, 1928.

———. "Still and Alleged Liquor Seized in Raid on Home," December 17, 1929.

———. "Surveyed on the Ice: The Secret History of the Kidwell Claim Published for the First Time," February 19, 1885.

———. "Symptoms of Grantism," February 5, 1879.

———. "They Want a Railroad," September 16, 1889.

———. "Trustees' Sale of the 'Seneca' Quarries and Farm in Montgomery Co., Md.," advertisement, April 3, 12, 14, 17, 19, 20, 1882.

Washington Times. "News from Boyds," April 13, 1904.

———. "News from Boyds," April 29, 1904.

Index

F

Freedman's Bank 13, 76, 79, 82, 84, 85, 86

G

geology 40
Georgetown University 14, 41, 106
Goode, George 111
Goode, James 9, 87, 89, 122, 123
Government Quarry 25, 41, 49, 66, 73, 93, 103, 104, 106, 113
Grant, Ulysses S. 13, 76, 78, 79, 80, 81, 85, 86, 89

H

Henderson's Castle 99, 101, 106
Henry, Joseph 46, 54, 85, 95
Historic American Buildings Survey (HABS) 116, 117, 119
Historic Medley District 10, 28
Hummelstown 88, 95, 99, 101, 106
Hurricane Agnes 128

J

John Wesley African Methodist Episcopal Zion Church 91

K

Kidwell, John 76, 79, 80, 81, 84, 86
Kiplinger, Austin 10, 119, 120, 121
Kiplinger, Knight 10, 28, 87, 119, 120, 122

L

Lab School 11, 13, 100, 106, 112
Lee, Wallace 72
Library of Congress 98, 104
Linthicum-Dent Mausoleum 91, 106
Luther Place Memorial Church 13, 91, 105

M

Mann, George 40, 98, 110, 113
Maryland Freestone Mining and Manufacturing Company 77
McClellan Gate 93, 104
Meigs, Montgomery 66, 91, 93, 108
Metropolitan Memorial Church 94
Metropolitan Wesley AME Zion Church 88
Montanverde 32, 34, 68, 84, 102
Montevideo 10, 26, 27, 28, 34, 38, 39, 49, 52, 61, 102, 116, 119, 120
Mosby, John Singleton 14, 63, 64, 65
Mullett, Alfred 41, 85, 94

N

National Union Building 95
Nourse, Alice 22, 62

O

Oak Hill Cemetery 11, 13, 32, 90, 91, 106, 122
Old Executive Office Building 41, 80, 82, 104
overseer's house 10, 26, 27, 49, 102, 107, 116, 120, 121
Owen, Claude 22, 114, 117
Owen, David Dale 47, 48, 49, 120
Owen, Robert Dale 44, 46, 47, 50, 53, 122

P

Panic of 1873 70, 76, 82, 83
Peter, Elizabeth Jane 34, 39
Peter, George 32, 68, 84
Peter, John P.C. 10, 22, 24, 26, 34, 36, 38, 39, 40, 47, 48, 52, 68, 77, 119
Peter, Robert 31, 32
Peter, Thomas (John P.C. Peter's father) 33, 34
Peter, Thomas (John P.C.'s eldest son) 39, 77, 78

INDEX

About the Author

G arrett Peck is a literary journalist, local historian and author. *The Smithsonian Castle* and the *Seneca Quarry* is his fourth book and sequel to *The Potomac River: A History and Guide*. He also leads tours of the Seneca quarry, as well as the Temperance Tour of Prohibition-related sites in Washington. A native Californian and VMI graduate, he lives in lovely Arlington, Virginia. Visit him at www.garrettpeck.com.

Visit us at
www.historypress.net